THE
*Archive Photographs*
SERIES

# BRISLINGTON

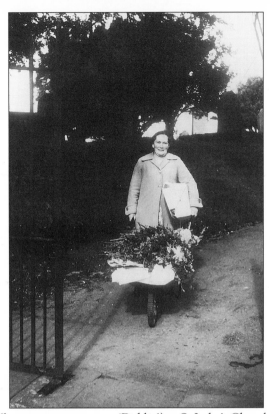

Miss Edith Williams (known to everyone as 'Diddie') at St Luke's Church gates, c.1970. Born at 'The Chestnuts' (see p. 36) in 1911, she has given over fifty years of devoted service to the people of Brislington – in particular the elderly and infirm – carrying on a tradition set by her family who have lived in Brislington for over 140 years. Diddie has had a lifetime of involvement with St Luke's where she was a member of the Parochial Church Council from 1960 to 1979, the first female sidesman in 1962 and verger for some fifteen years until ill-health forced her retirement in 1982. She was also local secretary of the Church of England Children's Society for over forty years. Her self-effacing work, care and concern will always be remembered by many with gratitude, admiration and deep affection. Her clear memory of people and events, and her extensive family collection of photographs formed the basis of the Brislington Conservation and Amenity Society archive in 1984.

THE
*Archive Photographs*
SERIES

# BRISLINGTON

*Compiled by*
Judith Chard, Mary Axford Mitchell and Jonathan Rowe
on behalf of The Brislington Conservation and Amenity Society

CHALFORD

First published 1995
Copyright © Brislington Conservation and Amenity Society, 1995

The Chalford Publishing Company
St Mary's Mill, Chalford,
Stroud, Gloucestershire, GL6 8NX

ISBN 0 7524 0351 6

Typesetting and origination by
The Chalford Publishing Company
Printed in Great Britain by
Redwood Books, Trowbridge

# Contents

# Acknowledgements

The Society wishes to thank the following people for their help with photographs:
Mary Batty, Ewart Beacham, John Bennett, Dorrie Brewer, Bristol United Press, Gordon Carey, Rt. Revd R.F. Cartwright, A.P. Chard, Judith Chard, Ena Coggins, John Corrigan, Phyllis Darby, Elsie Eden, Ralph Egaar, Winifred Emery, Margaret Fuller, Rosemary Gough, Stella Hallett, Doreen Hayward, Arthur Heal, May Hill, Maurice Jefferis, Muriel Leach, Mary Mitchell, Ray Petty, Jonathan Rowe, May Smart, Dr Oliver Russell, the Norah Fry Research Centre, Peggy Smart, Glenis Smith, Pat Sweet, M.J. Tozer, Jean Watson, Hannah White, Betty Williams, Diddie Williams, Nellie Wood.

# Introduction

Brislington is known to have been inhabited in Roman times because the remains of a Roman villa, dating from around AD 270-300, were found when Winchester Road was being built in 1899. The villa was probably the centre of a large estate and is believed to have been destroyed by fire about AD 367, perhaps after a raid by Irish pirates.

At the time of the Domesday Book's compilation in 1087, 'Brisilton' (there were various spellings until the present one was adopted in the early nineteenth century) was part of the manor of 'Cainesham' (Keynsham) but it became a manor in its own right in 1087 when William II gave it to Robert Fitzhamon, a nephew of William the Conqueror. The village grew up around a bridge over Brislington Brook, with a few wattle and daub huts and the old preaching cross which still stands today in St Luke's churchyard. There has been a church on the site of the present St Luke's Church since at least the thirteenth century. Originally it was served by the Augustinian Canons from Keynsham Abbey which was founded in about 1166. The present church dates from 1420 and was built by the 5th Baron Thomas la Warr. The la Warrs (later the de la Warrs) were lords of the manor from the late twelfth century to the late sixteenth century; they were to give their name to the state of Delaware in the USA. The north aisle of the church was added in 1819 and the church was extensively altered and lengthened in 1873-74.

In medieval times Brislington became a well-known place of pilgrimage, rivalling Walsingham and Canterbury. In about 1276 Roger la Warr founded the Chapel of St Anne-in-the-Wood near the holy well, which was said to have healing powers. The chapel was twice visited by Henry VII: in 1486, and again in 1502, accompanied by his queen, Elizabeth of York. It survived until it was dismantled in 1538 under Henry VIII's Dissolution of the Monasteries. The buildings fell into decay, but traces were still visible until early this century.

Brislington has had two manor houses. The medieval moated and fortified manor house of the de la Warrs stood in West Town Lane. Parts of this manor dated back to Saxon times. It later became known as Manor Farm and was demolished in 1933 to make way for the Imperial Sports Ground at the bottom of Sturminster Road. One large barn is all that survives. Langton Court, originally known as Brislington Farm, was developed in the seventeenth century, and was named by the Langtons (later the Gore-Langtons) who purchased the manor of Brislington from the Lacy family in 1667. In 1892 the Langton family inherited the title Earl Temple of Stowe, and they still hold the manor although in name only. Langton Court was virtually demolished in 1902 to build the Langton Court Arms on the same site in

Langton Court Road but the earliest part of the building, dating from around 1590, still survives.

In the mid-eighteenth century the older Brislington family names began to be replaced by the new landed gentry, and Brislington became a fashionable retreat for Bristol merchants 'when got up in the world'. They built many fine houses, some of which still stand. The Ireland, Hurle and Cooke families (later the Clayfield-Irelands and the Cooke-Hurles) became the main landowners in the late eighteenth century continuing to be so until well into this century.

Brislington became well-known for two buildings. Brislington House, believed to be the first purpose-built mental asylum for the humane treatment of the insane, was built by a Cornish Quaker, Dr Edward Long Fox (1761-1835) and opened in 1804. It continued to be run by the Fox family for nearly 150 years and closed in 1952. Since 1984 the house has been an elderly people's nursing home. The Arno's Court group of buildings on Bath Road, including 'The Black Castle', was built in the 1760s by William Reeve, a rich and eccentric Quaker copper smelter. In 1850 the house became a Roman Catholic convent and girls' reformatory school, remaining so until the late 1940s; it is now the Parkside Hotel.

In the nineteenth century Brislington was once called 'the prettiest village in Somerset' and it must indeed have looked very beautiful. Kingfishers could be seen on the banks of Brislington Brook, nightingales sang in St Luke's churchyard, children picked moondaisies in Holymead Fields, and the gentry shot hares and pheasants on their estates.

At the turn of the century there were sixteen main working farms in Brislington and several small-holdings, as well as market gardens, the main ones being run by the Ford family (in the Bloomfield Road area), the Coggins family at the Rock, and the Biggs at 'The Shrubberies'. Only five farmhouses survive today while a farm shop is still run from Hick's Gate Cottage on the Brislington/Keynsham border.

In the 1890s Brislington began to expand and houses were built at 'New Brislington' (St Anne's) and the Sandy Park area began to be developed. In 1898 part of the old parish of Brislington was taken into the Bristol boundary, but the area around the old village of Brislington continued to be part of North Somerset until 1933. Brislington had its own parish council from 1894 to 1933. In 1921 the Cooke-Hurle family of Brislington Hill House left the village (although most of their property was not sold until 1946) and the house was converted into flats; sadly it was bombed during a wartime air raid in 1941. Alfred Clayfield-Ireland, the last 'Squire of Brislington' died in 1923 and his large estate was broken up. Brislington Hall was demolished in 1933 and the site is now occupied by the B & Q building on Bath Road.

Industrial building began with the CWS butter factory in Whitby Road in 1904, followed by the Motor Constructional Works (later Bristol Commercial Vehicles) in 1912, and St Anne's Board Mills and Robertson's Jam Factory, both in 1914. Brislington Trading Estate began in 1927 with the building of Crittall's Windows, followed by others such as the Trist Draper 'Top Dog' works (1930), Smith's Crisps (1936), and John Wright & Sons, printers (1948). Most major industry closed in the 1980s, however, and many of the buildings have now been demolished.

Brislington was still very much a rural, semi-agricultural community until well into this century – the village smithy, for example, survived until the mid 1940s – and despite many buildings being lost through thoughtless demolition and wartime bombing, over sixty examples of the big houses, farmhouses and cottages still survive. Most people know Brislington as a village they pass through on their way to Bath, or which they visit to see films at the Showcase or to shop at Tesco or Great Mills or B & Q, but although Brislington is now a busy suburb of Bristol, it still retains something of its village past, and its history stretches back over a thousand years.

# One
# The Village and Beyond

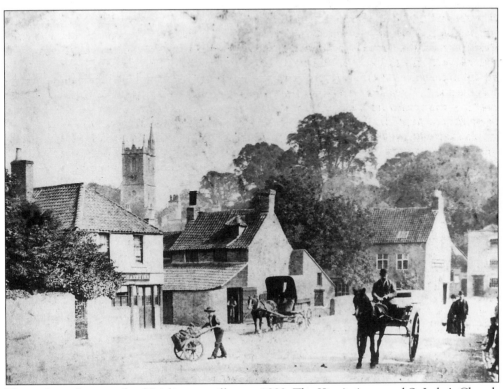

The earliest photograph of Brislington village, c.1880. The King's Arms and St Luke's Church are all that survive today.

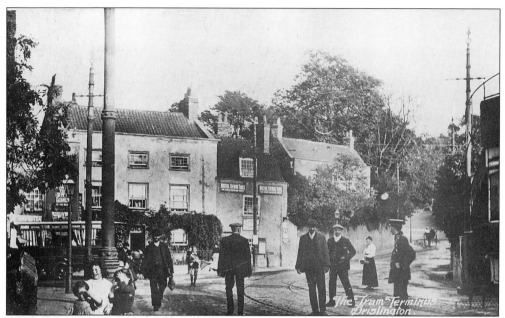

Brislington village, c.1910. Albert House in the centre became the post office in 1896. It was demolished in 1971, together with the adjoining shops and 'Homeside' on the right, to build the present shops.

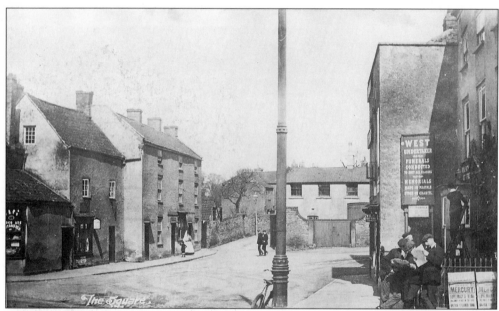

Brislington Square, c.1909. The West family ran the post office on the right for three generations and were also the village undertakers and monumental masons. Note the board advertising 'funerals conducted to suit all classes'. The shop with the woman and child outside survives today and was formerly the village butchers for over 150 years until 1979. The coach house and stables of Woodland House in the background were partly demolished in 1967 to widen Church Hill.

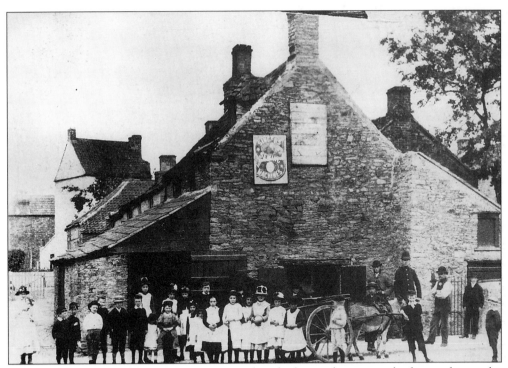

The smithy, c.1890. Village children pose with a donkey and cart outside the smithy on the corner of Grove Road (now Hollywood Road). It survived as a working concern until c.1945 and the site is now a garage.

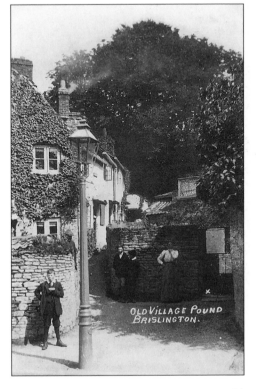

The village pound and Albert Cottages behind the post office, viewed from Brislington Hill, c.1900. The pound was used to hold stray animals and the stocks and whipping post stood here in the eighteenth century.

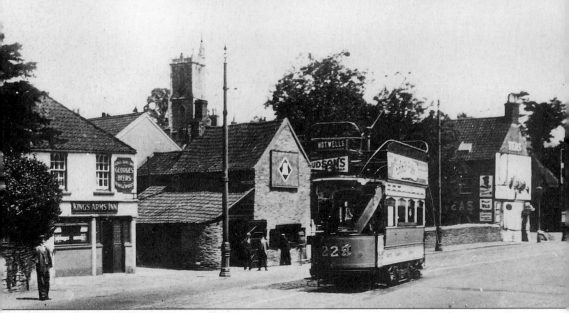

Brislington village, 1932. The Bristol tram line had been extended to the Square in 1900. Compare this with the earlier view on p. 9.

CHANGING ROAD NAMES IN THE VILLAGE

Hollywood Road, the turning on the right of the Kings Arms, is one of Brislington's oldest streets. At the time of the 1841 census it was named 'Kings Arms Lane', later becoming known as Grove Road (after 'The Grove' house). It was originally a 'dead end' with a large gate across the road, where the turning into Sherwell Road is now, leading into Bellevue Fields. What is now Brookside Road was also part of Grove Road. Nos 31-37 and 36-46 Hollywood Road were originally 'Hollywood Place' and Nos 25-29 and 16-24 were originally Bellevue Buildings'. About 1929, the whole road was named Hollywood Road and the cottages in the lane beyond 'the Hollywood chippy' became Brookside Road. About the same time, because of postal address re-organisation, Montrose Avenue became Montrose Park, Pendennis Road became Pendennis Park and Bellevue Road became Bellevue Park.

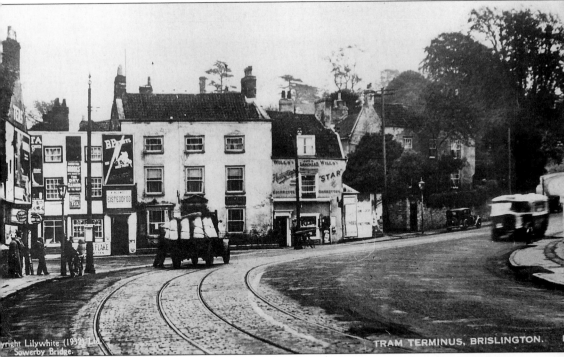

The Square, 1932. Jefferis' Newsagent and Sweetshop including, near left, the Tea Room appreciated by the tram drivers. Langmead's Store (later Reynolds Bros.) is to the right. 'Homeside', above right, dated from the eighteenth century and was at one time the home of Alfred Skilling, clerk to Brislington Parish Council.

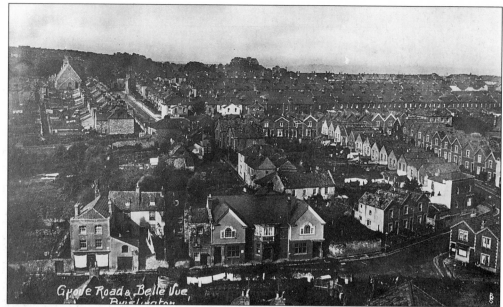

View from St Luke's Church tower, late 1920s. Grove Road, now Hollywood Road, is in the foreground. The Pilgrim, in the centre, was rebuilt in 1900 on the site of an earlier pub of the same name (dating from c.1840). Fry's Hill is next to The Pilgrim. Bellevue Park and Bellevue Terrace, Brislington's first purpose-built 'town houses' erected in 1878 to cater for the increasing population, are on the right. Brislington Congregational Church (now the United Reformed Church), built in 1901, is at the top left, on the corner of Montrose Avenue (now Montrose Park). Wick Road is on the horizon.

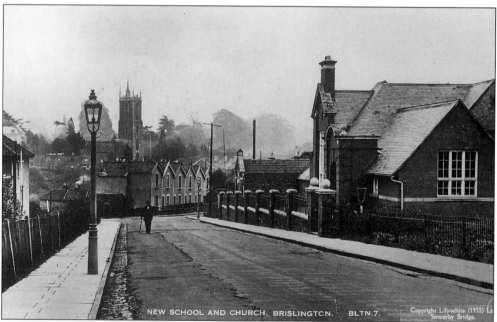

Hollywood Road, 1932. Hollywood Road Council School (now Holymead Infants' School) opened in 1913. Sherwell Road can be seen running away to the left. Brislington's earliest council houses were built here in 1927.

14

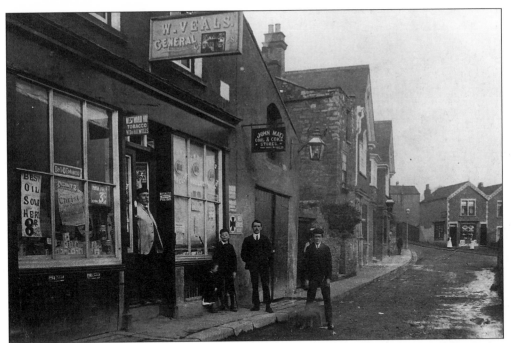

Grove Road, c.1905; it was renamed Hollywood Road in 1929. Mr W. Veal stands outside his general store at No. 13, believed to be Brislington's earliest purpose-built shop dating from c.1801 (see photograph of May Walters on p. 96). The shop on the far right has been Brislington's fish and chip shop since the early 1920s.

The Hollybush Inn, on the corner of Kenneth Road and Bristol Hill, c.1950. Around 1860 an earlier pub of the same name had opened on this site in a medieval building, one of several hostelries for pilgrims en route to St Anne's Chapel-in-the-Wood. The building was demolished in 1903 and replaced by the present pub. This photograph was taken from a glass plate being used as part of a garden cloche!

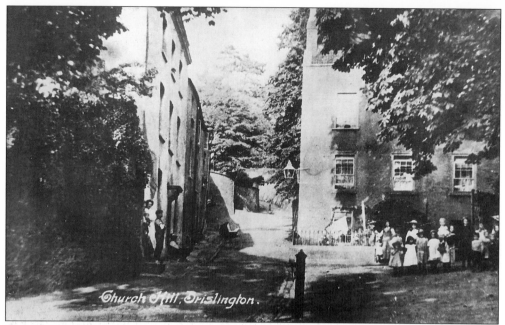

Church Row Cottages (now Church Parade), 1900s. Known locally as "Gossips' Row", they were destroyed by a wartime air raid in 1941 along with Myrtle Cottage on the right, now the entrance to Brislington Hill shops car park. Two houses built in 1986-87 now occupy the site of the cottages on the left.

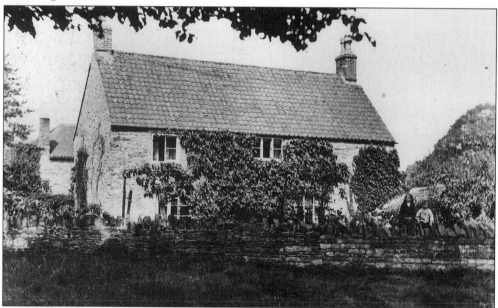

Keepers Cottage, c.1905. This view was taken shortly before Henry Knight and his family emigrated to Australia. Hector Stephen and his sister Winifred sit on the wall overlooking the field that is now a concrete forecourt. The house is believed to have been the first school in Brislington set up by Hannah More, and in 1853 it became the home of Richard Nicholls, gamekeeper to Squire Ireland (see page 98). The stable block of Brislington Hill House is visible in the background to the left.

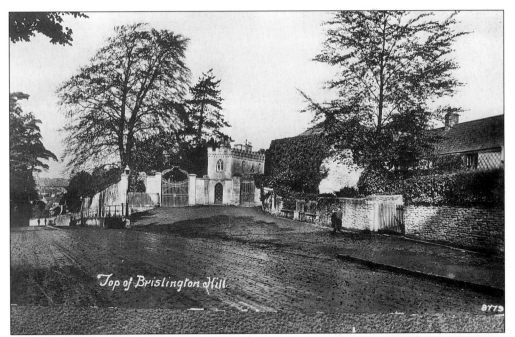

Top of Brislington Hill, 1926. The entrance gates and Gothic lodge of Brislington Hill House were demolished in 1966. Merryweathers elderly people's flats were built on the site in 1969. The ivy-covered stable block was demolished c.1934 to build Glenarm Road. Hill Cottage and Keepers Cottage, off right, both dating from the seventeenth century, still survive today, however.

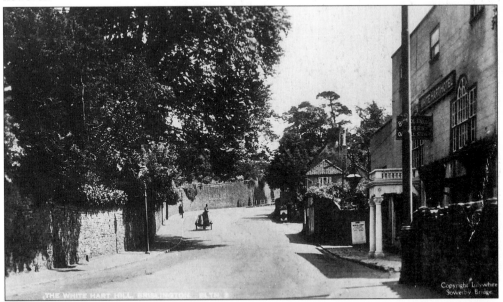

Looking up Brislington Hill (sometimes known as Bath Hill or White Hart Hill), c.1920. The White Hart opened as a coaching inn on the Bristol to London road in 1738. The ornate porch was taken down in the 1920s after it was damaged by a lorry. The high wall of Brislington Hill House on the left survived until 1968. Linton Farm, middle right, was demolished in 1936; this is now the entrance to Runnymead Avenue.

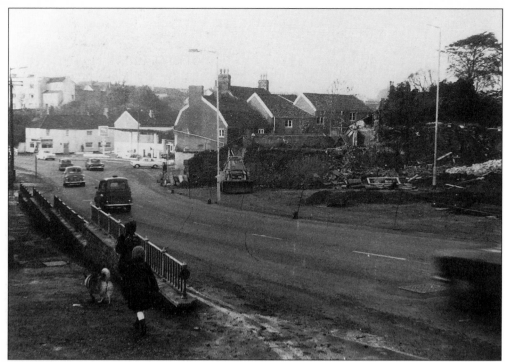

Re-development of Brislington Hill, 1969. 'Homeside' (see p. 13) has already been demolished, and the post office and shops await the same fate.

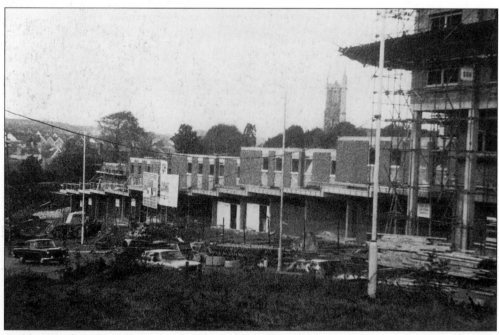

Building Brislington Hill shops and Gilton House flats, 1969.

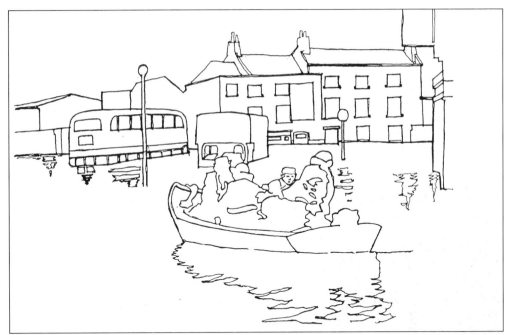

The 'Great Flood' of 10 July 1968. Sam Wyatt's picture shows the rescue by boat of passengers from a double-decker bus trapped by floodwater in the village. They were able to step from the emergency door of the upper deck into the boat!

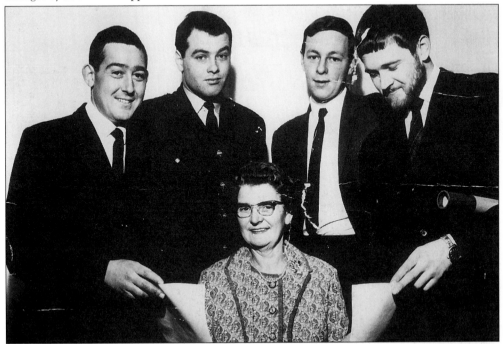

Presentation of Royal Humane Society testimonials to heroes of the 'Great Flood' of 1968: Michael Sweet, PC Wayne Butcher, Stephen Harris and Richard Sweet. These were awarded for their bravery in rescuing Mrs Elizabeth Bastin (centre) from her flooded home at No 6 Hollywood Road.

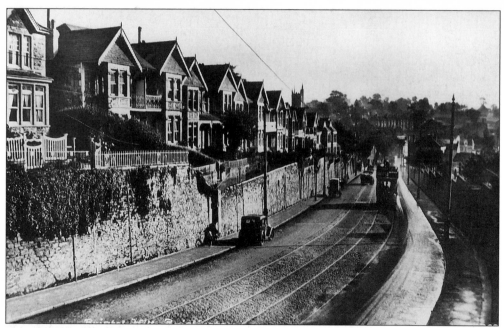

Bristol Hill in the 1930s. Glenarm Walk, recently built, can be seen in the middle distance.

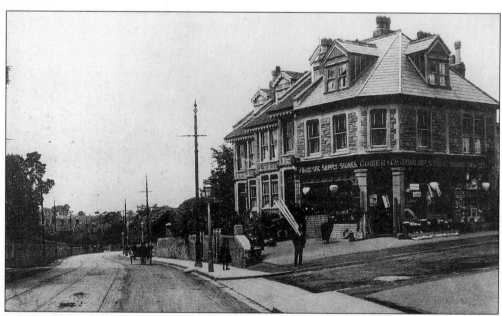

Kensington Hill, 1900s. Comer's Ironmongers, on the corner of Winchester Road, is now a post office.

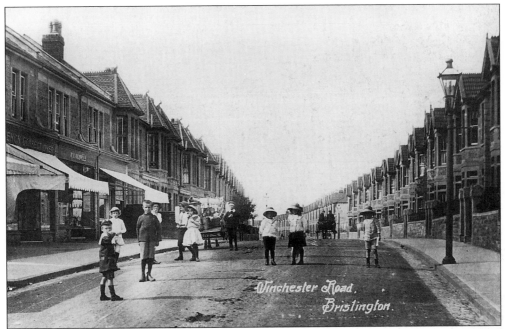

Children play in Winchester Road, c.1910. This is the site of Brislington's Roman villa, dating from about AD 300, remains of which were discovered when Winchester Road was being built in 1899.

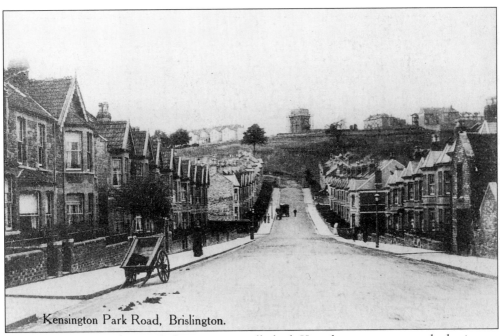

Kensington Park Road, Brislington.

Kensington Park Road, c.1905, showing a partially-built Knowle water-tower on the horizon.

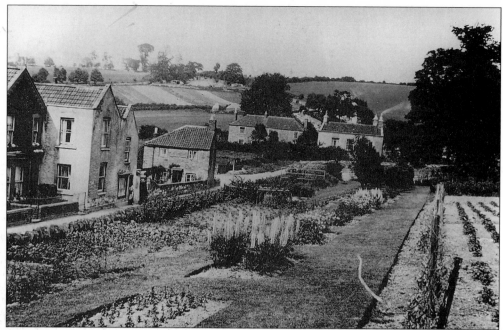

School Road in the 1920s as seen from St Luke's Church School gardens. Elm Tree Cottages, on the far left, survive alongside No 114, the village baker's shop from the 1860s until the late 1930s. Holly Cottages, in the centre, still survive on the corner of Clayfield Road. Note that Broomhill on the skyline is still completely rural.

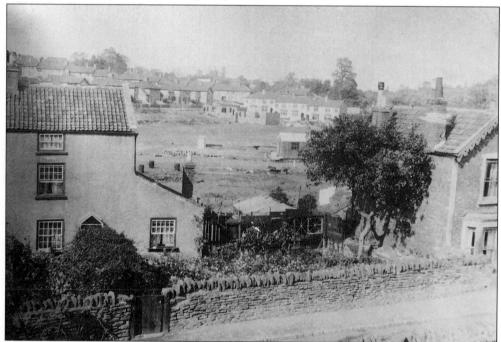

School Road, c.1935. Step House, on the left, was demolished to make way for a modern housing development, c.1950. Elm Tree Cottages survive on the right. Partly-built houses in Jean Road and Edna Avenue can be seen in the distance.

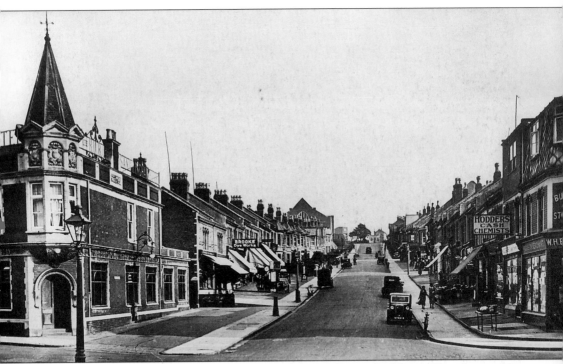

Sandy Park Road, c.1935 and still a busy shopping centre today. St Cuthbert's Church is visible at the top of the hill on the left. The Sandringham Hotel, on the near left, was opened in 1899. To the right of the tree in the distance is the entrance lodge of Wick House (now demolished).

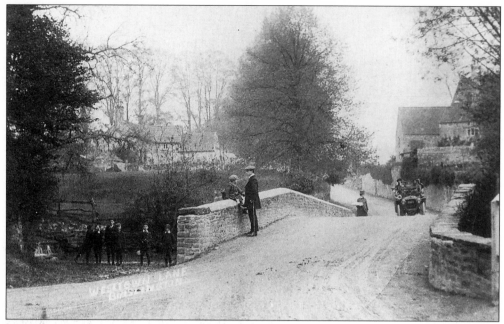

West Town Lane, c.1910. This remained a leafy country lane until the first houses were built in 1928. The waterfall in Brislington Brook can still be seen today. West Town Cottage on the left, home of the Bawden family for many years, was demolished to build modern houses in 1966. West Town Farm on the far right was demolished in 1953 to allow the construction of West Town Lane Infants' and Junior Schools. Stone from the farmhouse was used to face part of the junior school.

Water Lane, c.1915. The tree in the centre can still be seen today. The Tesco store, opened in 1985, is now off right, with Homemead Drive off left, beyond the gate.

William Gordon Chown (1885-1973) on the double stile in Holymead Fields, 1903. This is the lane along the bridge over Brislington Brook from Kenneth Road to Callington Road. West Town Lane is on the horizon.

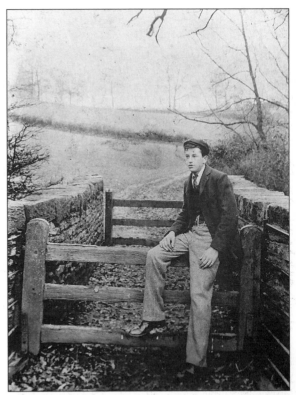

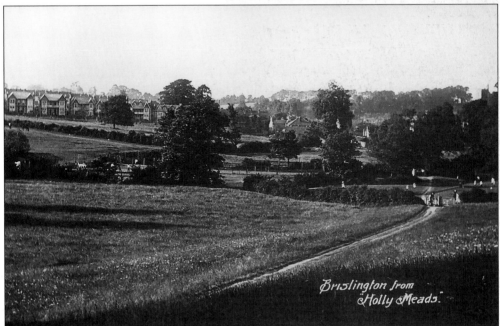

Holymead Fields, c.1910, looking from West Town Lane towards Bristol Hill on far left. Medieval pilgrims met here for the last part of their journey to St Anne's Chapel-in-the-Wood, hence the name. This area is now covered by Callington, Kenneth, Hulse and Warrington roads, built between 1935 and 1939.

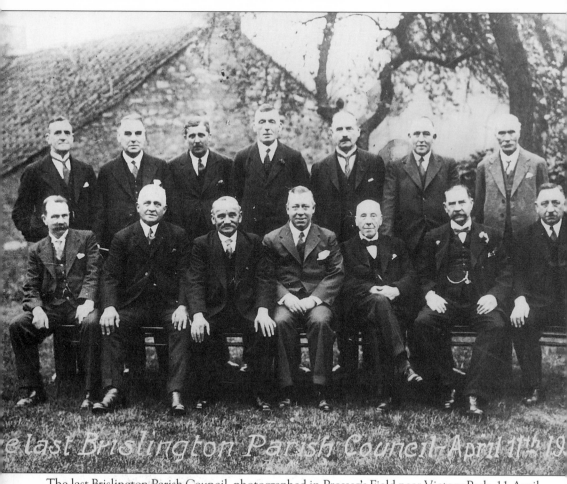

The last Brislington Parish Council, photographed in Prosser's Field near Victory Park, 11 April 1933. Oakenhill Cottages can be seen in the background. Brislington had its own parish council from 1894 to 1933 when the whole of Brislington was taken within the Bristol City boundary. It was responsible for the efficient running of village affairs and services. From left to right, back row: Arthur Palmer, Percy Dyer, Dr Francis Elliot Fox (Brislington House), Arthur Miller, William Salway, Rowland Grainger, Alfred Weare. Front row: Wilfred Stone, Tom Fuller, Ernest Poole, Albert Sherman (Chairman) Alfred Skilling (Parish Clerk), Mr Warner, Captain James Grant.

# Two

# Houses
# Great and Small

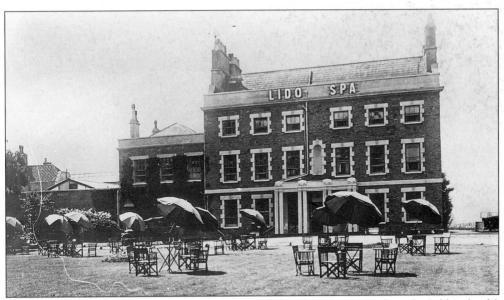

Brislington Hall, Bath Road, 1932. The home of the Irelands, (later the Clayfield-Irelands) from c.1770 to the 1920s. The family were the largest landowners in Brislington for over 150 years. After the death of the last 'Squire', Alfred Clayfield- Ireland in 1923, Brislington Hall was sold and later re-opened c.1930 as 'The Lido Spa' hotel and nightclub. This enterprise was not a success, however, and the house was demolished in 1933. The five-acre gardens and thirteen acres of parkland are now partly covered by the Hungerford Road estate. The B & Q store now stands on the site of the house itself. The lodge was demolished in 1927 to build Crittall's Windows on the junction with West Town Lane, the first factory on what was to become Brislington Trading Estate.

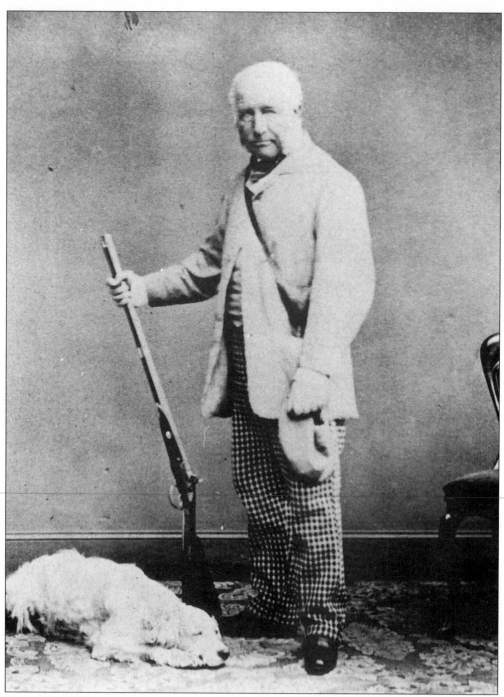

James Clayfield-Ireland (1804-1864), c.1860, 'Squire' of Brislington from 1825 to his death in 1864. He assumed the name of Clayfield-Ireland in 1827 by royal licence in order to comply with the will of his maternal grandfather James Ireland (1724-1814) which stated that he could not inherit the estate if he did not do so. In 1832 James married Letitia Priaulx (1812-1886), eldest daughter of Thomas Priaulx, founder of the Guernsey Banking Company. They had fourteen children, three of whom died in infancy, and all of them died childless.

Alfred Clayfield-Ireland (1851-1923), the last 'Squire' of Brislington, with his gardener William Pollard c.1920. He inherited the estate in 1898 on the death of his brother James. The family were kindly, but certainly eccentric, and many stories have been handed down, including the fact that Alfred and his sisters belonged to various religious denominations and used to return home on Sundays from their devotions, (Alfred being Anglican) and squabble through lunch about their various forms of service. Alfred was a tall man who walked with a stoop, quietly-spoken and rather shy. After his death in 1923, the family estate passed to a cousin, Lt. Col. James St George Priaulx Armstrong (1874-1939) who had no interest in Brislington and so after 150 years the estate was sold and broken up.

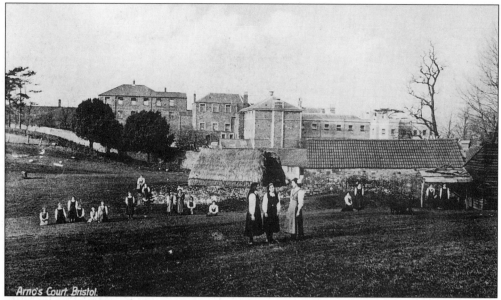

Arno's Court, Bath Road, c.1910. The original house on the far right was built in the 1760s by William Reeve, a Quaker copper smelter. In 1850 it was acquired by the Sisters of the Order of the Good Shepherd and became a Roman Catholic convent and reformatory for women and girls until c.1946. The Victorian additions to the building in the centre were demolished c.1960.

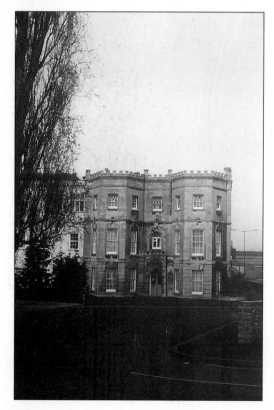

Arno's Court, c.1970. After being closed as a convent, the house was used as offices by Bristol City Council. In 1960 it opened as Arno's Court County Club and Hotel. It soon became a popular nightclub, and a swimming pool, casino and restaurant were later added. In 1987 it was renamed The Parkside Hotel.

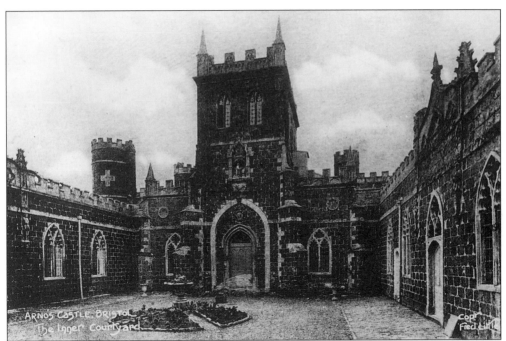

Arno's Castle (now the Black Castle), c.1910. It was built in 1763-4 by William Reeve as servants' quarters, stables, brew-house and laundry, in the form of a mock castle with blocks made of waste slag from his copper works. The eighteenth century novelist, Horace Walpole called it "the Devil's Cathedral" on a visit to Brislington in 1766. The castle has been a farm, market garden and antique showroom. In 1918 it became the social club of the Bristol Tramway Company, and in 1977 it was opened as a public house. Recently completely restored, it re-opened in August 1995 as a family restaurant.

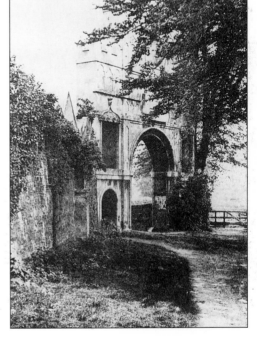

Arno's Gateway, 1900s. Built around 1766 by William Reeve as a gateway to the Black Castle, until 1908 it contained statues of Edward I, Edward III, Geoffrey, Bishop of Coutance and Robert, Earl of Gloucester. These were donated at this time to Bristol City Museum before the gate was moved in 1912. In 1995 the arch was restored and replica statues put in place.

Brislington Hill Garden

Brislington Hill House, c.1910. This was the home of the Cooke-Hurles, another of Brislington's land owning families. Built by John Hurle (1755-1824) c.1798, it remained the family home until 1921. John Hurle's niece Susannah married Joseph Cooke of West Town House in 1805, and their son Joseph took the name Cooke-Hurle in 1855. After the family moved to Kilve Court near Bridgwater in 1921 the house was converted to flats, but was demolished after being bombed in a 1941 air raid. Gilton House flats, built in 1969, now stand on the site of the house.

The grounds of Brislington Hill House, c.1910. In the mid-1930s, the extensive gardens were built on, becoming the Glenarm Road area.

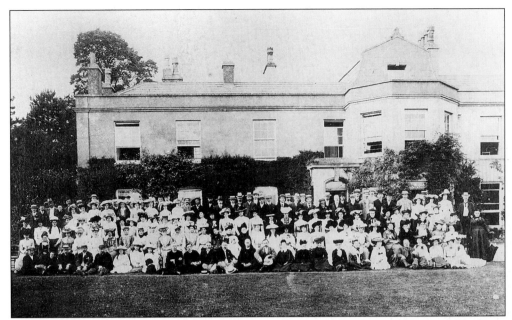

Southfield House, off the main Bath Road near the Flowers' Hill government buildings, c.1905. This was the home of Joseph Cooke-Hurle Jnr., (1859-1930) from 1886 to 1911. The occasion may be the christening party for his only son Reginald (1904-1975). Mr Cooke-Hurle is pictured with a moustache in the centre of the front row holding a hat in his hand; many other Brislington personalities are also present. In the late 1930s the house was taken over by Ripley & Son Ltd, portable building manufacturers, and was eventually demolished in the early 1970s.

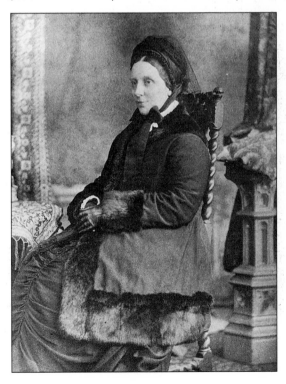

Mrs Lilian Margaret Cooke-Hurle (nee Thomas 1868-1906), first wife of Joseph Cooke-Hurle. She had four daughters and a son, Reginald, who was born in December 1904. Her carriage was drawn home from the top of Bristol Hill to Southfield House by men of the village to show their joy at the birth of an heir. She tragically died from consumption aged 38. A stained glass window in her memory is in the Lady Chapel of St Luke's Church.

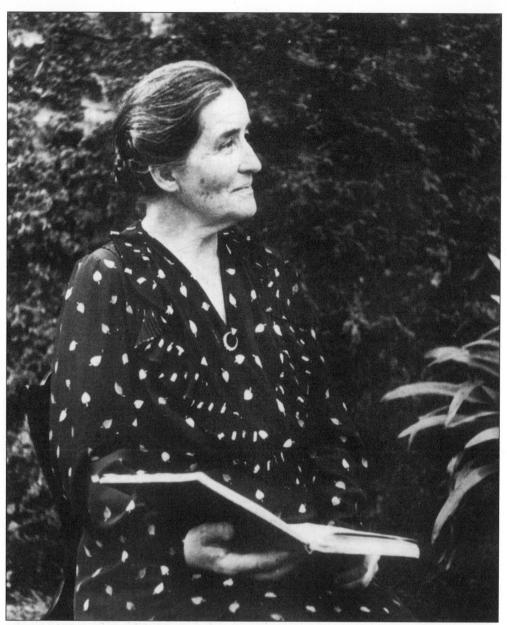

Mrs Norah Lilian Cooke-Hurle (née Fry, 1871-1960). The daughter of Francis Fry of the chocolate manufacturing company, she married Joseph Cooke-Hurle in 1915. After graduating from Newnham College, Cambridge, she became a great educationalist and pioneer in nursing and mental health and a great benefactor to Bristol University on whose council she served for fifty years from 1909. She was the virtual founder of Somerset County Nursing Association in 1902, the first woman councillor on Somerset County Council in 1918, first woman Alderman in 1932 and one of the first women JPs. A tireless crusader in the cause of mental health, she was instrumental in securing the passage of the Mental Deficiency Act in 1913. She was also manager of Tone Vale Hospital, Taunton for many years and through the Norah Fry Hospital in Shepton Mallet and the Norah Fry Research Centre in Bristol her name is deservedly perpetuated.

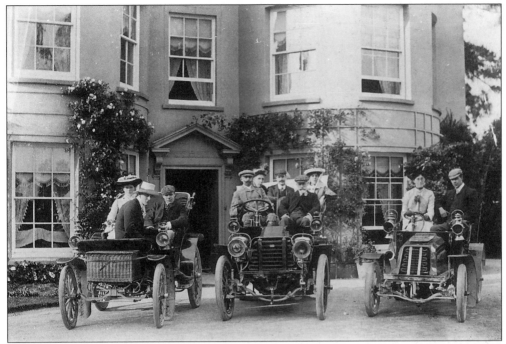

'The Elms', Bath Road, c.1903. The home of Charles Allen, partner in the Chappell-Allen Corset Manufacturers of Redfield, Bristol from c.1895 to c.1904. Mr Allen is on the right in the middle car. His son Percy and daughter-in-law Isabelle (see p. 36) are in the car on the left. These are believed to be the earliest cars to be seen in Brislington.

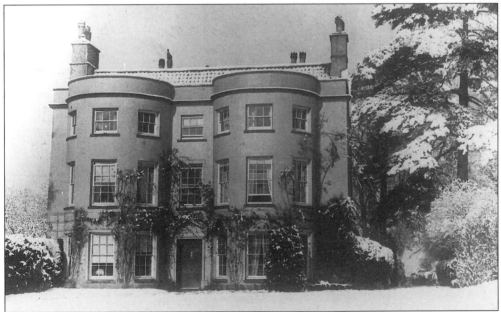

'The Elms', c.1914. The Spear family were the final occupiers here from 1912 to 1934; Mr Egbert Spear was managing director of the Pensford and Bromley Colliery. The house was badly damaged by fire in 1938 and demolished the following year. It stood roughly where the Hussman Refrigerator Factory is now, to the rear of Bryan Bros.' car showroom.

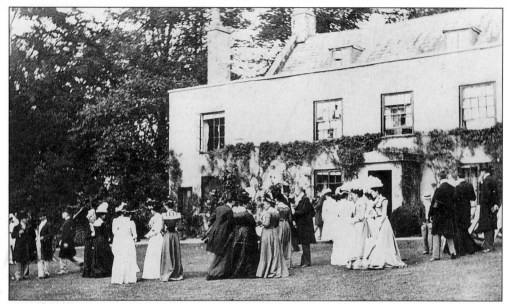

'The Chestnuts' (now off Bonville Road), 1 August 1900, showing the wedding reception in the garden for the marriage of Isabelle Vowles and Percy Allen. The Vowles and Williams families lived here from 1879 to 1983. The house is believed to date from c.1668.

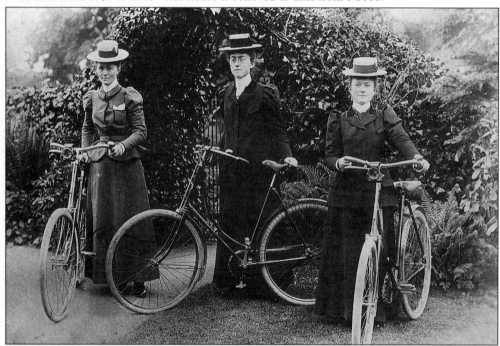

Emma, Frances and Edith Vowles in the garden of 'The Chestnuts', 1890s. They once cycled to Wells and back on these bicycles! Emma (1869-1947) married Robert Adams Norris, a Bristol timber merchant in 1905 and lived in Woodland House, Brislington village. Edith (1871-1940) married Henry Williams of Eagle House in 1905 and continued to live at 'The Chestnuts'. Frances (1875-1947) in the centre, remained unmarried and lived with Edith and Henry and their daughter Edith (better known as 'Diddie', see p. 2).

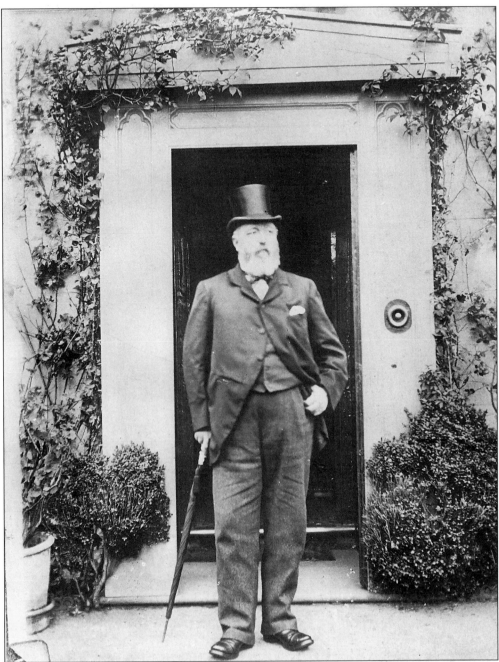

George Vowles (1838-1904), 'gentleman farmer', at the front door of 'The Chestnuts', 1890s. He married Elizabeth Adams of Woodbridge House (now The Woodlands), West Town Lane in 1866. They lived at Oakenhill Farm before moving to 'The Chestnuts' in 1879, and had seven children, three of whom died in childhood. Mr Vowles was a manager of St Luke's Church School, a founder member and onetime chairman of the parish council; he still holds the record as the longest serving churchwarden at St Luke's – 21 years from 1868 to 1889. To quote his obituary in the parish magazine he was 'one of our best known and respected parishioners'.

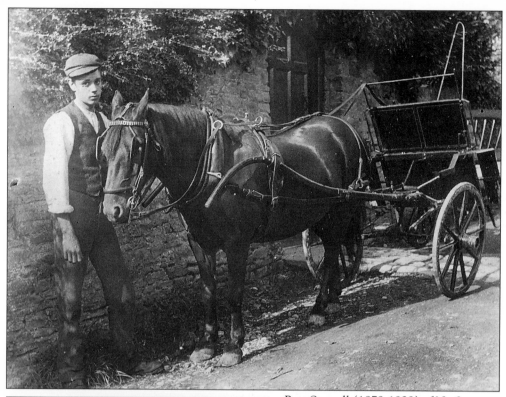

Bert Stowell (1879-1929) of No 2 Oakenhill Cottages, stable lad and later gardener at 'The Chestnuts' from 1894 until his death, pictured with Charley the horse outside the garden door.

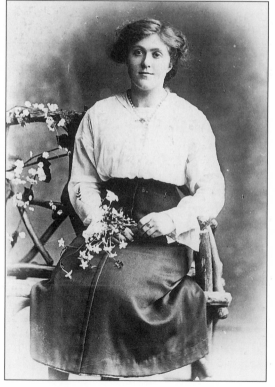

Margaret ('Nancy') Coggins (later Mrs Harry Miller, 1895-1940), nurse to Miss 'Diddie' Williams, and subsequently general maid at 'The Chestnuts' between 1911 and 1923. She was one of the five members of the Coggins family killed in the air raid on Rock Villa in 1940.

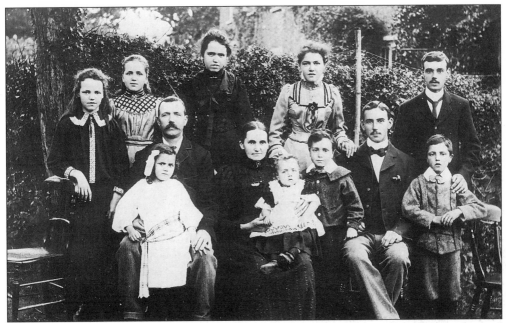

The Stowell family outside Oakenhill Cottages, c.1900. The cottages have been modernised and still exist near Oakenhill Farm off Bonville Road. The Stowells lived at No 2 from the 1880s to the 1940s. George Stowell (centre) was a farm labourer for the Brean Brothers at Oakenhill Farm and six of the ten children went into domestic service. The family were bellringers at St Luke's Church for three generations.

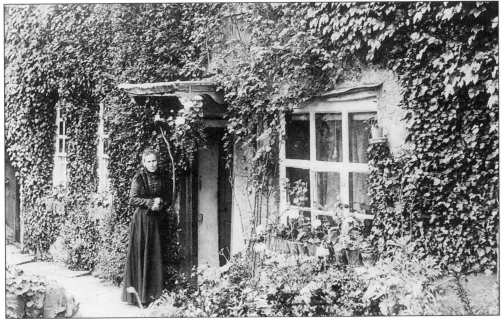

Mrs Regina Langmead (1856-1929) at her front door, Churchside Cottage, Church Hill, 1895. The building, which at this time was two cottages facing the churchyard, still survives. Mrs Langmead's husband William was coachman to Revd Alfred Richardson, vicar of St Luke's between 1890 and 1902.

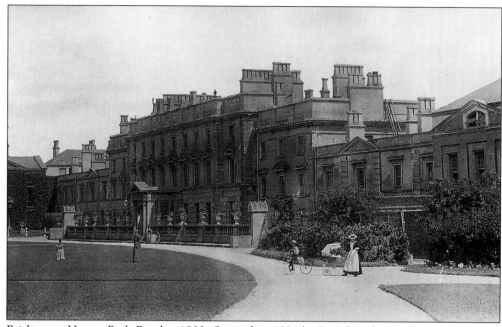

Brislington House, Bath Road, c.1900. Opened in 1804 by Dr Edward Long Fox as one of the first asylums for the humane treatment of the insane, it continued to be run by the Fox family until 1952, after which it became a nurses' hostel. Since 1984, it has been a nursing home for the elderly. The ivy-covered chapel, added in 1851, can be seen on the far left.

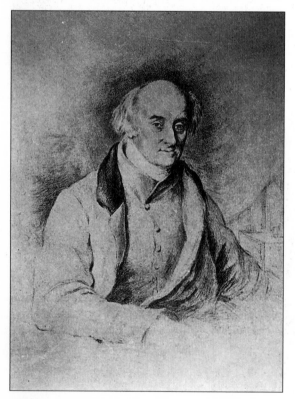

Dr Edward Long Fox (1761-1835). A Cornish Quaker, he moved to Bristol in 1786 and set up a practice in Castle Green and later Queen Square. In 1794 he took charge of a private asylum at Downend, and purchased part of Brislington Common in 1799 for £4,000 to build his own asylum. He was also a physician at Bristol (Royal) Infirmary from 1786 to 1816, and was once called upon to attend George III during one of the monarch's mental relapses. Married twice, he had twenty-two children, four of whom became doctors. Dr Fox retired in 1829 and went to live at Heath House in the grounds of Brislington House (see page 42) where he died in 1835 aged 74.

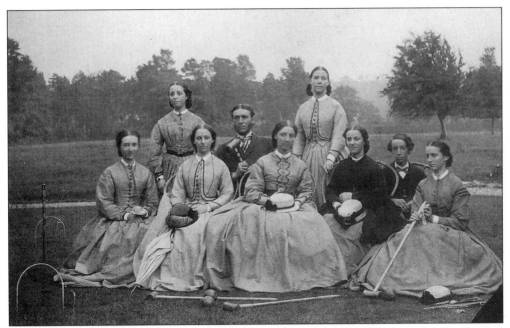

Some of Dr Edward Long Fox's sons and daughters playing croquet in the grounds of Brislington House in the 1860s.

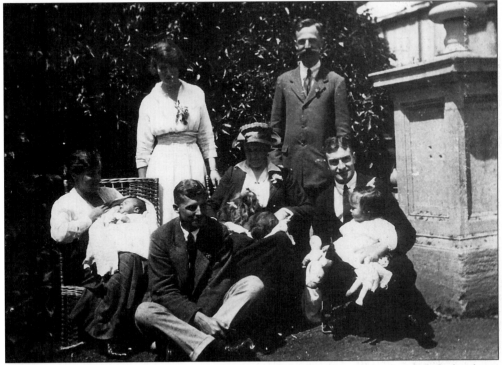

The Fox family, July 1919. Mrs Bonville Fox (centre), her son Tom (standing right), daughter-in-law Edith (standing left), daughter Betty Hattersley-Smith with baby Duncan, son Dr Elliot Fox (sitting cross-legged), the last Dr Fox, who ran the asylum from 1929 until his death in 1947, son-in-law Richard Hattersley-Smith and daughter Susan on the right.

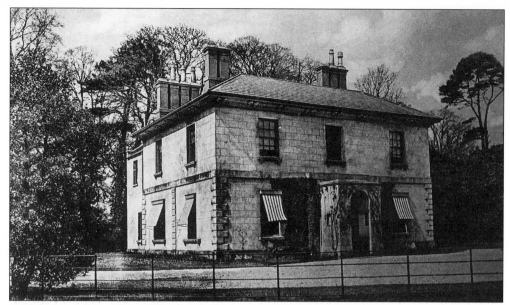

Lanesborough Cottage, c.1906. It was built in 1816 for an Earl of Lanesborough who was a patient of Dr E.L. Fox. One of several houses built for patients in the grounds of the asylum, it later became the home of Tom and Edith Fox until their deaths. It was demolished c.1975 and the Bristol Harlequins RFC clubhouse now stands on the site off Broomhill Road.

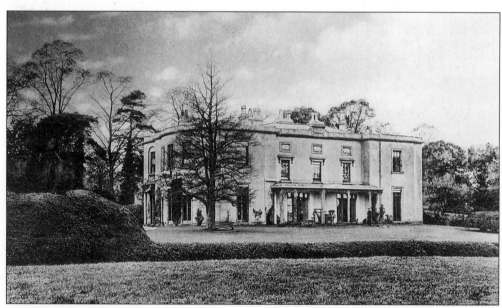

Heath House, c.1906. Built c.1825 it became the retirement home for Dr E.L. Fox. It stood off Broomhill Road and was demolished after suffering a direct hit in an air raid in 1940.

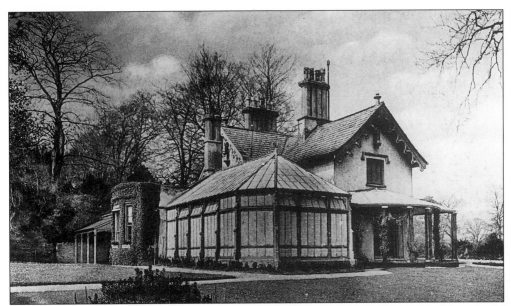

Carysford Cottage (now Swiss Cottage), c.1906. Built in 1819, it still stands off Ironmould Lane. It was the home of Mrs Ethel Mary Fox, wife of Dr Francis Elliot Fox and former matron of the asylum, until her death in 1989.

'The Beeches' in Broomhill Road, c.1906. Built c.1840, both patients and members of the Fox family lived here over the years. During the Second World War a Royal Engineers bomb disposal unit was stationed there and during the Blitz several bombs fell in the grounds of Brislington House; in 1940 the asylum was visited by King George VI. 'The Beeches' was later purchased by the Christian brothers who built St Brendan's School (now the sixth form college) in the grounds in 1961. The house, itself, became a training centre for the South West Gas Board in 1981.

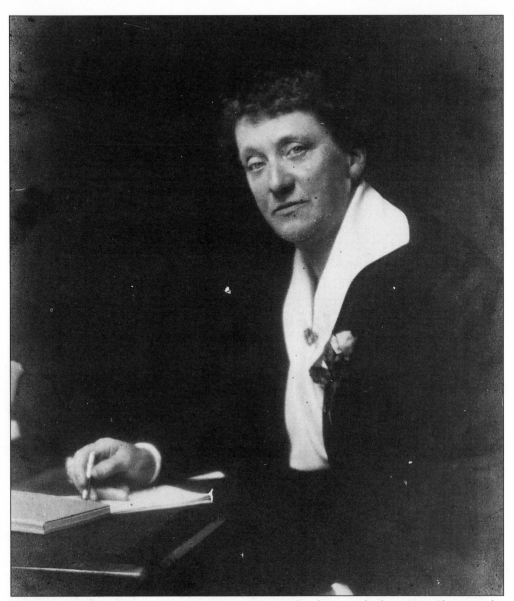

Mrs Bonville Fox (née Annie Danger, c.1851-1942), photographed c.1920. She was the daughter of Thomas Danger of Gotley Lodge, Brislington who was Clerk of the Peace for Bristol from 1871 to 1878. In 1886 she married her cousin Dr Bradley Bonville Fox; they had three children. In 1902, after her husband's death, she took over the running of Brislington House. She founded Brislington Women's Institute in 1918 and continued to be its president for the following 25 years, despite being confined to a wheelchair in later life. Mrs Fox was also a patron of Brislington Cricket Club and Brislington Rifle Club. There is still a competition for the Fox Challenge Cup which she presented to the Rifle Club in 1907. She instigated and chaired the committee that set up the Brislington War Memorial in 1922, and gave her name to the 5th Bonville Scouts (now St Luke's). Mrs Fox continued the tradition of the Fox family as village benefactors, although she did have a somewhat eccentric side to her nature: for example, on one occasion she caught two small boys scrumping apples at the asylum, cut out the seats of their trousers and sent them home, telling them to send their mothers back for the pieces!

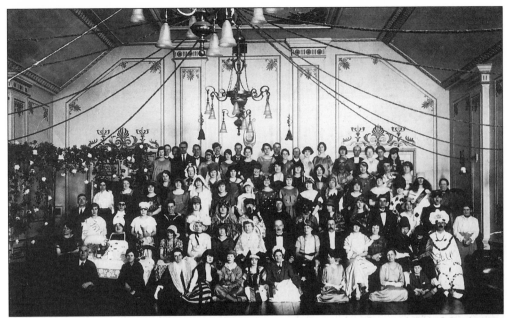

Staff fancy dress party in the ballroom of Brislington House, c.1920. The ballroom was added in 1866. Mrs Bonville Fox is in the centre of the second row sitting next to Dr James Rutherford, a doctor at the asylum from 1909 until his death in 1943.

The Quaker cemetery at the back of the old Smith's Crisps site, c.1906. The cemetery was established in the late 1690s and was later purchased by Dr E.L. Fox of Brislington House as a private cemetery for his family and their retainers. He was buried there in 1835. In 1964 it was sold by Fox family descendants and became part of Western Freights' premises. Although nothing now remains, it is hoped that the boundaries will be marked and a commemorative plaque put in place.

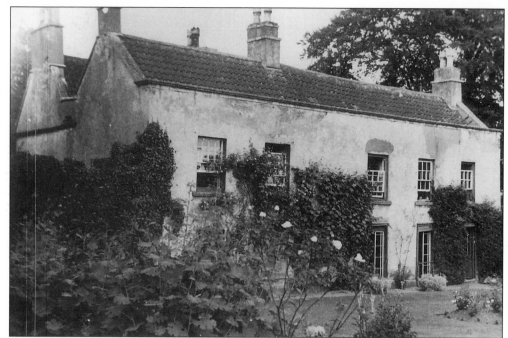

Hick's Gate House, Bath Road on the Brislington-Keynsham border, 1920s. The house is believed to date from c.1618 with eighteenth and nineteenth century additions. It is said that Royalist soldiers were hidden there during the Civil War and that Judge George Jefferies stayed there during the 'Bloody Assizes' which followed the Monmouth Rebellion of 1685. The house later became a toll house on the old turnpike road, the area being known as 'Redland Gate'. The present name is a corruption of "Hix's Gate", a Mr William Hix being the occupier c.1820.

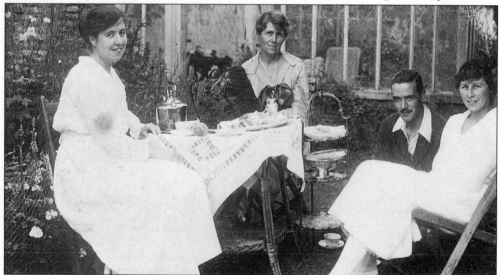

Members of the Gough family and friends enjoying afternoon tea in the garden of Hick's Gate House, 1920s. The Goughs were occupiers from 1914 until 1957 and bought the house from the Cooke-Hurles in 1946. Mr Harold Gough was headmaster of Bristol Grammar Preparatory School (1908-35). Mrs Gough, centre of picture, bred fox terriers and chows. Their daughter Marjorie, far right, ran a private school at the house for some years.

46

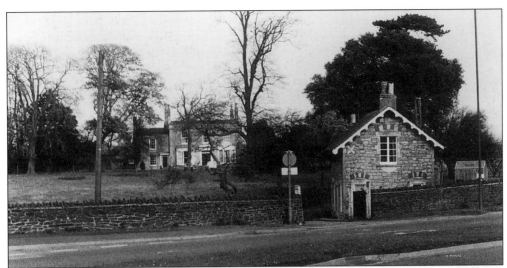

Oakleigh, Bath Road in 1986. This attractive Regency house with its later entrance lodge still stands opposite Hick's Gate House. From 1911 to 1958, it was the home of Arthur Cole who ran the Bristol Bone Manure Company in Feeder Road, known to Bristolians for generations as "Coles' Bone Yard". His son Reg founded Eudon Nurseries, now Wyevale Garden Centre, c.1927. In 1962 the house was converted into two.

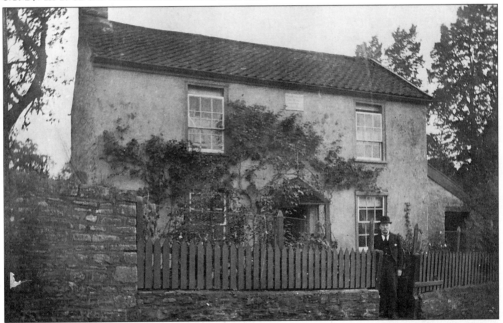

"Nelson's Glory", School Road, 1900s. There are two versions of how it got its name: one that it was built in 1805 at the time of the Battle of Trafalgar, the other that a sailor who had served on *The Victory* came to live there and put up the plaque 'Let Every Englishman Do His Duty', a corruption of Nelson's signal before the battle. The house was let to William Beaven in 1871 who bought it from the Gore-Langtons at auction in 1881 and it has been occupied by his descendants ever since. His son-in-law, William Culverwell, an attendant at Brislington House Asylum, is standing at the garden gate. William's wife, Rosina, was sextoness at St Luke's Church from 1921 until 1938.

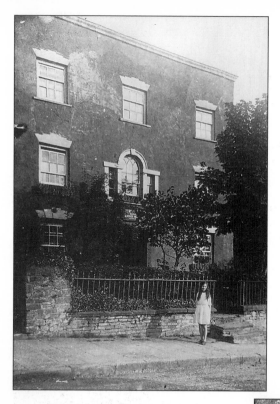

Freeland House, Church Hill, early 1920s. It is believed to stand on the site of the pilgrims' hostelry where Henry VII is said to have rested on the way to the Chapel of St Anne-in-the-Wood in 1486. It was later owned by the Coggins family and occupied by Robert Chown, builder and decorator, from the 1880s; his daughter Ethel is pictured here outside. In 1940 the house was bombed and later demolished. Nos 14 and 16 Church Hill now occupy the site.

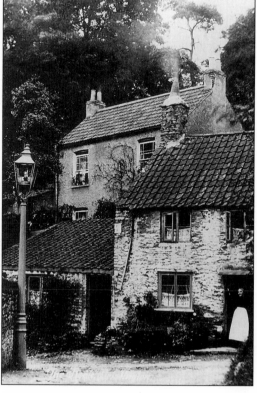

The Rock, c.1910. Fir Tree Cottage in the background still survives and has been extended. Mrs Mary Ann (Granny) Ford stands at her cottage door. She was well known for her herbal remedies and 'wart charming'. After her death in the early 1930s the house became derelict but traces survived until the 1970s.

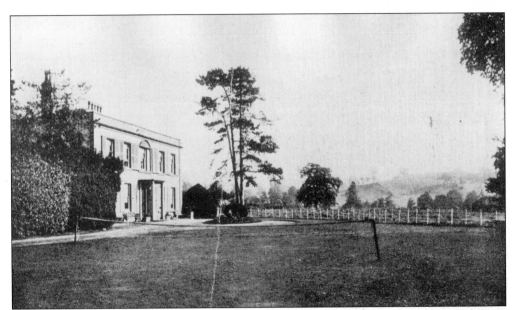

West Town House, West Town Park, c.1930. Parts of the house date back to c.1600, the front being added in the eighteenth century. It was the home of Joseph Cooke (1782-1834) who married Susannah Hurle in 1805. The Cooke-Hurles owned the property until c.1923. Flowers' Hill, now part of Knowle golf course, can be seen on the right.

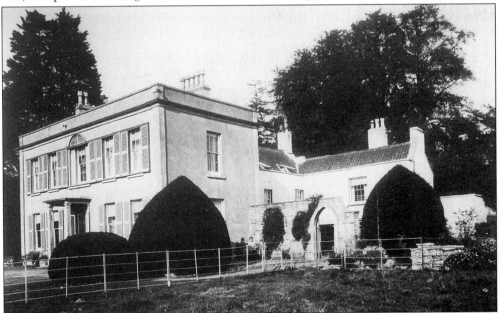

West Town House in the 1920s. Joseph Corrigan, managing director of Burleigh Ltd, printers, bought the house around 1923 and lived there until his death in 1941. His wife and two of his sons can be seen in the centre near the kitchen garden wall that still survives. From 1942 to 1953 the house was an elderly people's home known as Uganda House. In 1962 it was converted into two houses. Building in the grounds began in 1936 with further council house development in 1947, and in the early 1960s houses were built on the tennis court to the right of the picture.

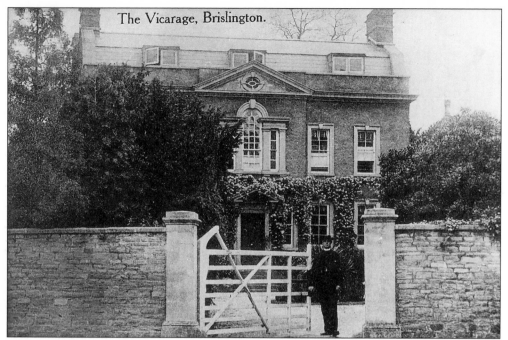

The Vicarage, Brislington.

Church Hill House, c.1905. Built in 1700, it later became a private boarding school for boys – Church Hill House Academy (1799-1856). In 1896 it was presented to the parish by James Clayfield-Ireland as St Luke's vicarage, which it remained until 1981 when the present vicarage and the houses of St Luke's Gardens were built in the grounds to the rear. Revd Sydney Gilliat, vicar from 1902 until 1906, is seen at the gate.

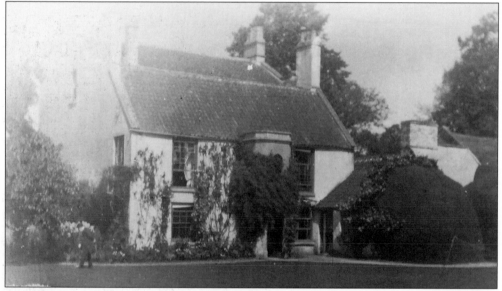

'The Hollies', off West Town Lane, c.1880. This seventeenth century house was the home of Revd George Leopold Cartwright (1815-1896), seen on the far left, for over fifty years. He was resident curate of St Luke's from 1839 to 1880. In 1925 it became the clubhouse of Knowle Golf Club; it was demolished in 1955 when the new clubhouse and houses in The Fairway and Lucas Close were built.

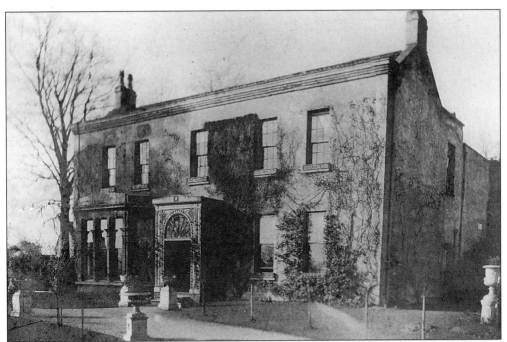

Gotley Lodge, Water Lane, c.1900. Built by John Coryton Gotley in the early eighteenth century, it was the home of Revd William Daniel Conybeare (1787-1857), resident curate of St Luke's from 1819 to 1826, the founder of modern geology and later Dean of Llandaff. In 1936 the house was sold to Harold Greenhill who built houses on Brislington Hill and Runnymead Avenue; his family continued to live there until a few years ago. The house is presently being repaired.

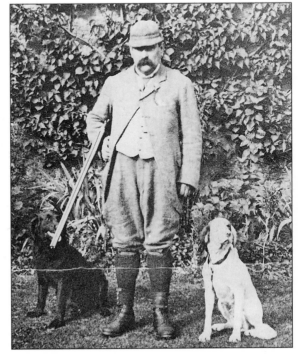

Mr Robert Adams Norris, ready for a local shooting party, c.1900. Mr Norris of Wickham and Norris, timber merchants, lived at Woodland House, Church Parade from 1880 until his death in 1910. His widow Emma (see page 36) sold the house to Walter Butt, a well known Bristol grocer, who lived there until his death in 1938. From 1943 to 1983 it was the home of the Parry family, father Leonard (d. 1955) and his son Alfred, a well known Brislington personality (d. 1983). It has now been converted into flats.

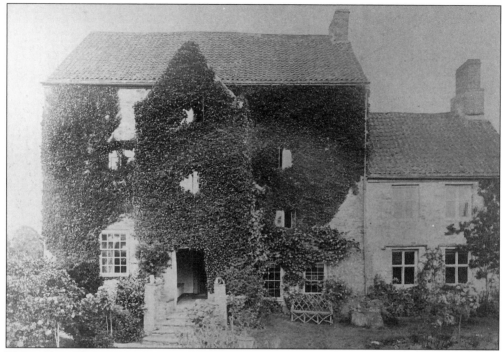

Manor Farm, West Town Lane, c.1873. This was the manor house of the de La Warr family, Lords of the Manor of Brislington (1189-1586) and dates back to at least the fourteenth century. The house was demolished in 1933 to make way for the Imperial Sports Ground. A barn on the corner of Sturminster Road is all that survives today.

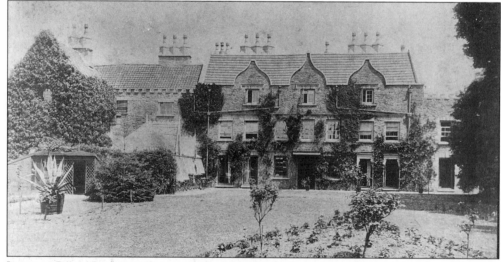

Langton Court, Brislington's second manor house, in the 1880s. The Lacy family of Shipton-under-Wychwood, Oxfordshire bought the manor of Brislington in 1586. Built between 1590 and 1610, it was extended c.1620 and again after 1667 when it was purchased by Sir Thomas Langton, a Bristol merchant, Alderman, and Mayor in 1666. His descendants became the Gore-Langtons in 1783, inheriting the title Earl Temple of Stowe in 1892. With the exception of the oldest part, on the far left, which still survives in Highworth Road, it was almost completely demolished in 1902 to build the Langton Court Hotel on Langton Court Road.

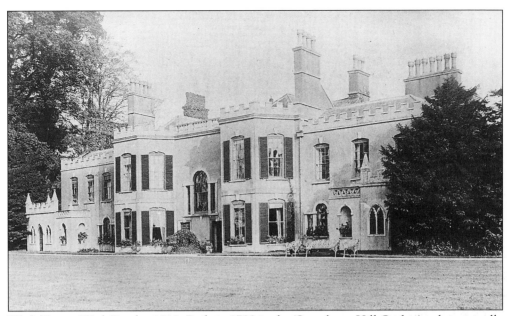

Wick House, Wick Road, c.1912. Built in 1790 in the 'Strawberry Hill Gothic' style, originally with over sixty acres of pleasure grounds, the entrance lodge (demolished in the 1930s) stood at the junction of Wick Crescent and the top of Allison Road. It was the home of Thomas Harding, partner in Colthurst & Harding, paint manufacturers, and his family from 1881 until 1924. Mr Harding, who died in 1900, is commemorated by a stained glass window in St Luke's Church. The house was opened by the Duchess of Beaufort as a Church of England Children's Society home in 1925. It closed in 1981 and became the elderly people's home it is today.

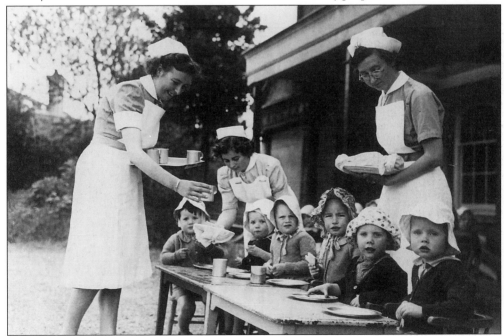

Wick House, 1949. From left to right the nurses are: Jean Hoskins, Dorrie Hartley and Beryl Faulkner.

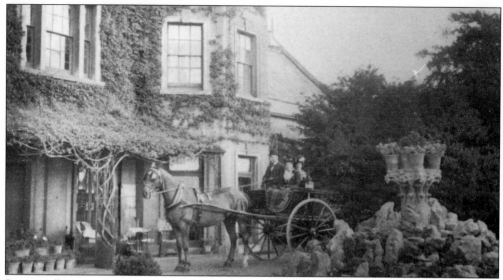

Broomwell House, Wick Road, c.1900. Built in the 1760s, it originally stood in fifteen acres of land now covered by the Sandy Park area and the Sutton estate. It was the home from 1823 until his death of George Weare Braikenridge (1775-1856), merchant, collector and antiquarian. He commissioned the collection of drawings that give us a unique record of Brislington in the 1820s. Alderman William Proctor Baker (1834-1917) lived there from 1868 to 1896; he was Lord Mayor of Bristol 1871-72. A corn merchant, his firm later became Spillers & Co. Sitting in the cart is George Henry Johnson, market gardener, who succeeded him as occupier. The house was demolished in 1915 and stood on the site of Nos 240-286 Wick Road. The entrance lodge survived until 1928.

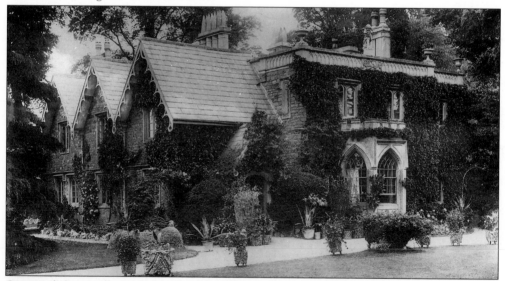

'Lynwood' (originally known as Gothic Villa), now No 625 Bath Road, c.1910. A fine small 'Tudor Gothic' villa set in a good example of a Victorian garden, it was the home of the Owens family from 1899 until 1918. Mrs Owens was a great worker for St Luke's Church and a manager of the church school between 1904 and 1918. In the 1950s Lynwood was occupied by Eric Blake of Blake's Bakeries, and the Exclusive Brethren Meeting House was built in the grounds when it was sold in 1966. Sadly the house, a listed Grade II building, has been unoccupied since 1985.

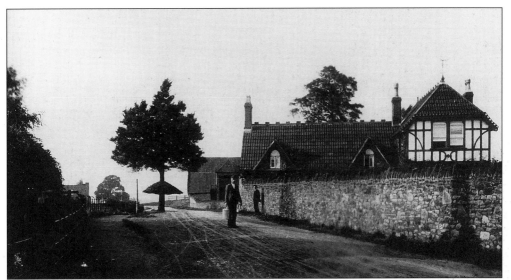

Birchwood Lodge, Birchwood Road 1900s. The earliest part of the house dates from 1650. The extension on the right was added c.1886 when it became the summer residence of James Sinnott (1845-1944) a solicitor and Brislington landowner. He built the first houses in First Avenue and was instrumental in opening St Anne's Park railway station in 1898. Houses have been built in the gardens to the rear in recent years. The 'umbrella tree' in the centre was cut down in the 1950s.

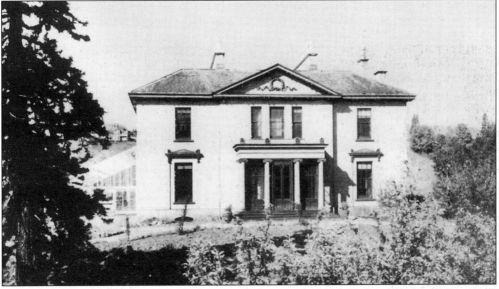

Kensington House, Bath Road, c.1935. It was built around 1810 by John and Mary Brown (née Cater), parents of Dr Walter Brown of Parramatta, New South Wales, and the grounds covered much of the Kensington Park and Hampstead Road areas. In the 1840s it became the home of Richard Jenkins Poole-King (1799-1874), a Bristol shipping merchant who was Lord Mayor of Bristol in 1844-45. His widow lived there until her death in 1884. In 1935 it became the clubhouse for St Christopher's Church. During the Second World War, it was taken over by a tank regiment and later by the Territorial Army. After finally being used by a greeting card firm it was demolished in 1973 for the present PDSA building.

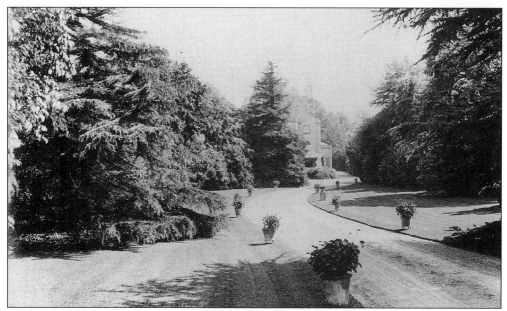

Entrance drive to 'The Grove', Wick Road 1880s. The eighteenth century house still stands at the top of Bristol Hill. This, and the following photographs, come from a set of thirty showing the house and grounds just over one hundred years ago. The home of the Ricketts family, Bristol glass manufacturers c.1795-1862, it continued to be owned by the family until 1900 when the extensive grounds were built on to become Grove Park Road, Pendennis Park, Montrose Park and Bristol Hill. The entrance lodge stood between today's Manworthy Road and Trelawney Road.

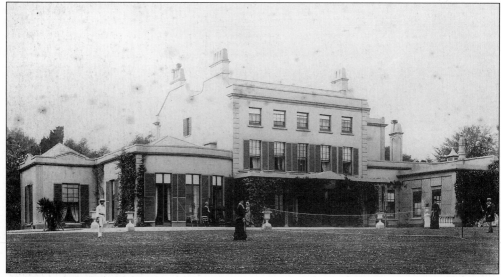

Members of the Cripps family playing tennis at 'The Grove', 1880s. Mr Richard Cripps, an Italian marble importer, was the last private occupier of the house from 1878 until 1899. It then became a children's home and from 1906 to 1978 was the church hall of Brislington Congregational Church (now the United Reformed Church). The central part of the house has since been converted into flats; the wings on the right and left were demolished at the turn of the century.

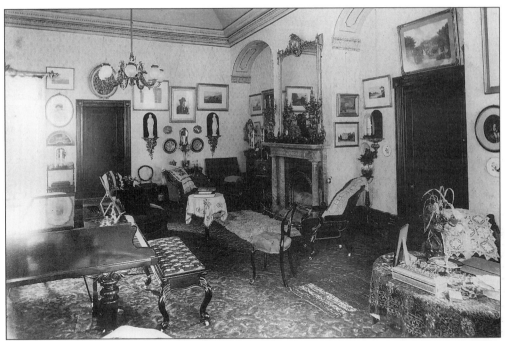

Drawing room at 'The Grove' 1880s. This is a rare photograph showing a drawing room of the Brislington gentry.

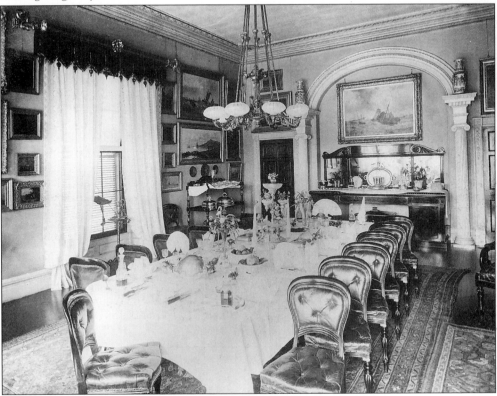

Dining room at 'The Grove' 1880s. The table is set for a dinner party.

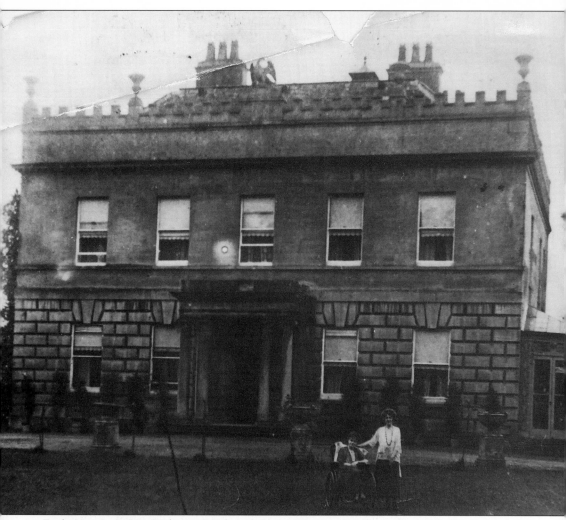

Eagle House, 1920s. Built in 1769 by Abraham Jones, a distiller in Redcliffe Street, Bristol, it became the home of George Thomas (1791-1869) a Quaker and wholesale grocer about 1840. He was a founder and benefactor of Bristol General Hospital, largely responsible for the building of the original Colston Hall in Bristol, and an original director of Bristol Waterworks Company. His widow continued to live at Eagle House until her death in 1893, when Henry Williams (1842-1912) came to live there. He was a well known architect at the turn of the century and designed many Bristol buildings including part of Clare Street, the Stock Exchange and the old Western Daily Press building in Baldwin Street. His unmarried daughters, Miss Daisy and Miss Amy (seen in the photograph), sold the house in 1933 and it was demolished the following year to build Eagle Road. The stone eagle on the façade and some stone urns still survive.

# *Three*
# Church and Chapel

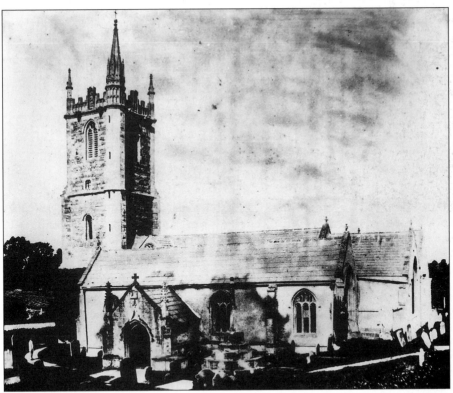

The earliest photograph of St Luke's, 1860s. Note the sundial over the porch and, above, the choir gallery skylight. The churchyard was extended on the left in 1875. There has been a church on the site since at least the thirteenth century. The present building, dating from the c.1420s was founded by the 5th Baron Thomas La Warr (d. 1426). His parents Roger and Elizabeth are depicted in the statues in the central tower niche. The north aisle was added in 1819 and the building extensively altered internally in 1873-74.

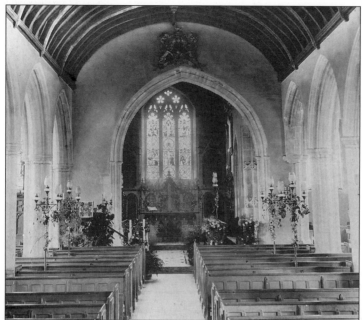

Interior of St Luke's, 1901, probably decorated for Harvest Festival. The altar stained glass window depicting the story of the Crucifixion was erected in 1874 in memory of W.H.P. Gore-Langton (1824-73), Lord of the Manor of Brislington from 1847 until his death. It was destroyed in a wartime air raid and replaced in 1948 by a different design.

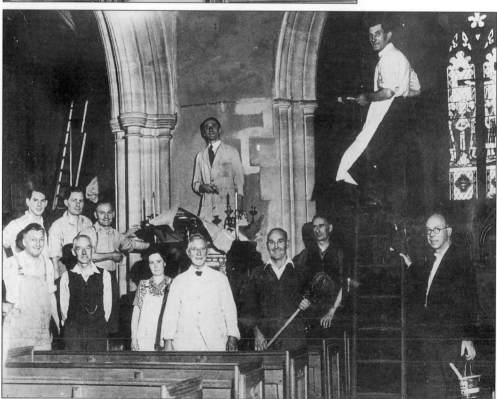

Decorating the interior of St Luke's Church, August 1949. Note the new altar window on right. From left to right, back row: Eric Jones, Fred Whatley, Percy Wood, Joe Britton (in the pulpit), Bert Enticott (on the steps). Front row: Cliff Hawketts, Monty Perry, 'Diddie' Williams, Harry Williams, Arthur Owen, Stan Clarke, Canon Norman Hulbert (vicar from 1945 until 1955).

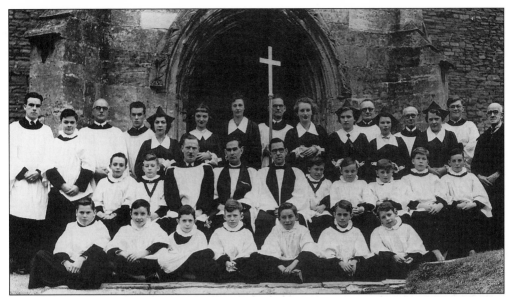

St Luke's Choir, c.1955. Revd Osmund Moss, vicar from 1955 until 1965 is pictured centre, with, on the right wearing glasses, Revd John Gibbs (curate here 1955-57 and later Bishop of Coventry 1976-85). Bert Roach, on the left of Revd Moss, was the organist at St Luke's 1937-40 and 1953-59.

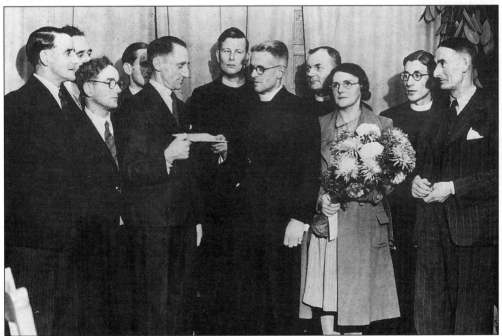

Farewell presentation of a cheque to Revd G.R. Fooks, vicar of St Luke's 1941-44, at the Grove Hall on 16 December 1944. From left to right: Albert Ball (Vice Chairman of the Church Council), Revd E. Blythe (Congregational minister), A.J. Richardson (City Mission), C. Thuxton (Methodist), Joe Britton (church-warden), Revd P. Leigh (curate at St Luke's), Revd Fooks, Revd E. Smart (vicar of St Anne's), Mrs Enid Fooks, Revd W. Thomas (curate at St Luke's), S.E. Clarke (church-warden).

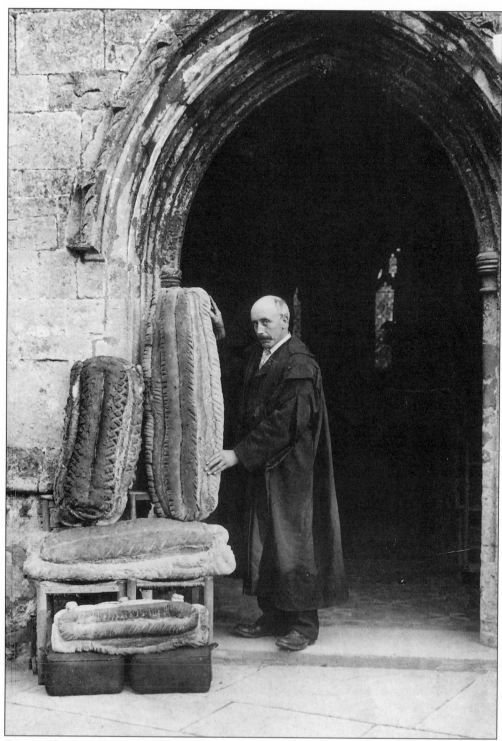

George Chown, Sexton of St Luke's between 1899 and 1938, pictured here c.1920 with Harvest Festival loaves. The large loaf was cut up and given to the poor as part of the old parish charities.

Revd Alfred Richardson's Young Ladies' bible class around the preaching cross in the churchyard, 1890s.

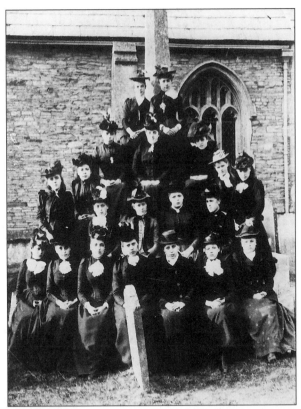

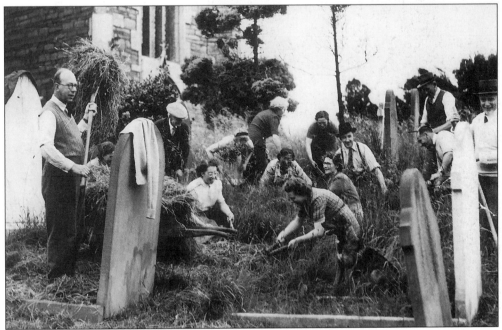

Grass cutting in the churchyard, early 1950s. From left to right: Canon Norman Hulbert, Albert Ball, Doris Clarke, Enid Bearder, Olive Russ, Ruby Bennett, 'Diddie' Williams, Bert White, Ethel Roberts, Mrs Wotton, Bert Enticott, Cyril Palmer, Harry Williams.

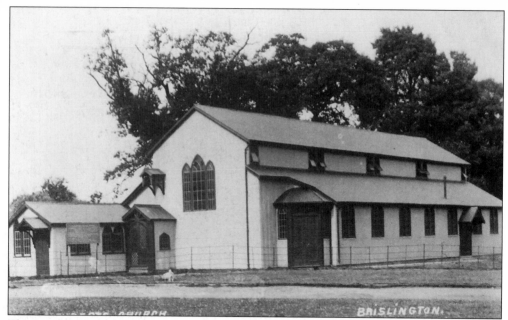

The original 'Iron Mission Church' of St Cuthbert's in the 1920s. It stood at the top of what is now Allison Road (opposite the present church) from 1906 until 1932. Known locally as 'the tin church', it had first been used as the original St Anne's Church in 1896.

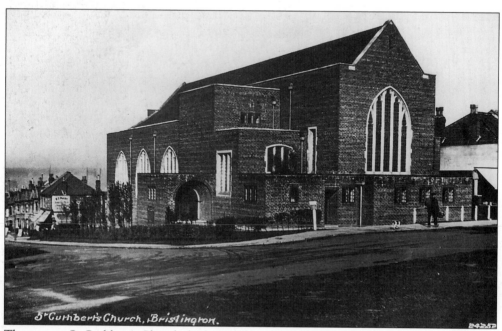

The present St Cuthbert's Church, built in 1933, at the top of Sandy Park Road.

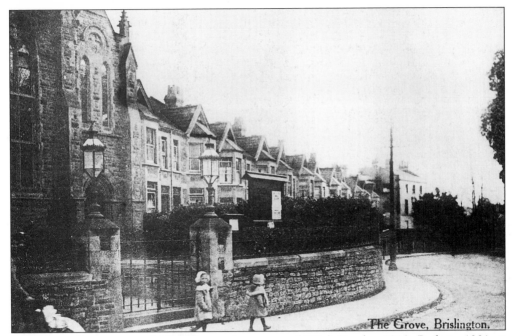

Brislington Congregational Church, on the corner of Wick Road, c.1910. Built in 1901, it replaced the old chapel in Kenneth Road (now part of the Hollybush Inn) which had been the site of the barn where the original church was founded in 1796.

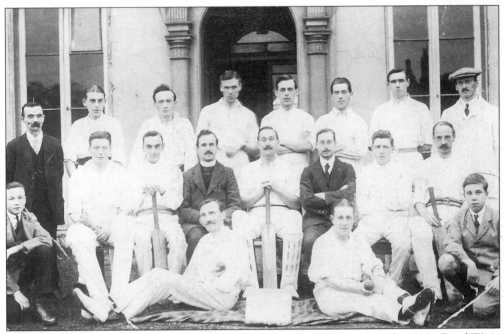

Brislington Congregational Church cricket team, outside 'The Grove', early 1920s. Revd W.A. Painter, centre, was the Minister here between 1919 and 1936.

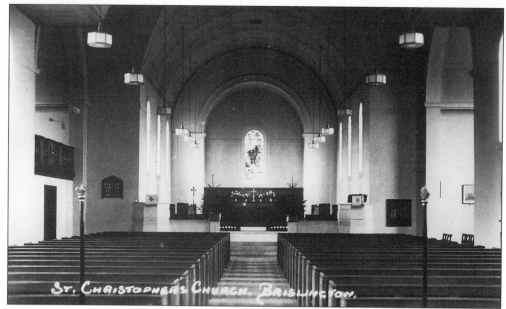

Interior of St Christopher's Church, Hampstead Road, 1930s. Opened in 1931, it replaced the original 'tin church' alongside it which had been built in 1921. After 1931, this became the church hall. The church was re-arranged internally in 1989.

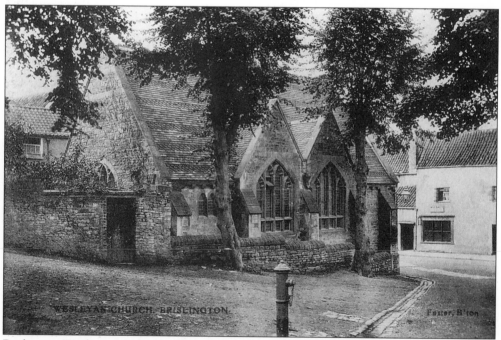

Brislington Wesleyan Methodist Chapel in 1910, seen from Church Parade. Opened in 1885, it closed in 1967 and was demolished in 1971. Miss Millie's take-away now stands on the site.

# Four

# Schooldays

St Luke's Church School (Brislington National School), School Road, c.1910. Built in 1859, it replaced the original schools opened in 1822 on three separate sites for boys, girls and infants. It served the village for 83 years until it was badly damaged by bombing in 1942. It was demolished in 1953 and Rock Close was built on the site in 1968. The school-master's house, however, still survives. On the right is the original Brislington fire station set up in 1902.

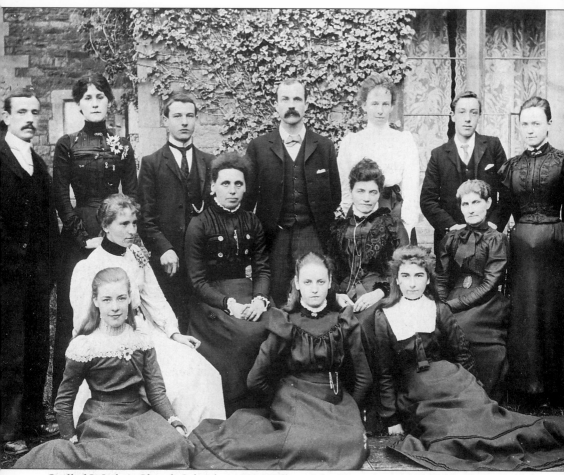

Staff of St Luke's Church School, c.1900. William John Porter, centre with the moustache, was the boys' headmaster 1892-1923. Miss Emma Martin, far right, was the infants' head until 1913 when she became headmistress of the new Hollywood Road School. Sitting to the right of Lucy Beacham, in the white dress, is Miss Alice 'Guppy' Perks, the infamous girls' headmistress from 1891 to 1917 who 'drank like a fish', hence the nickname. She used to send a girl down to The Pilgrim two or three times a day to bring back beer in a jug, and one girl had to come to the school-house each morning to lace up her stays. Apart from her excessive drinking, it is said that she swore, was slovenly and not very clean! She was eventually forced to resign in 1917 after complaints from her assistant teachers about her excessive caning of the children. On one occasion she cut a child's hand open with a ruler and drew blood. The girl's father went up to the school to complain to Miss Perks in the evening, but they both ended up getting drunk together!

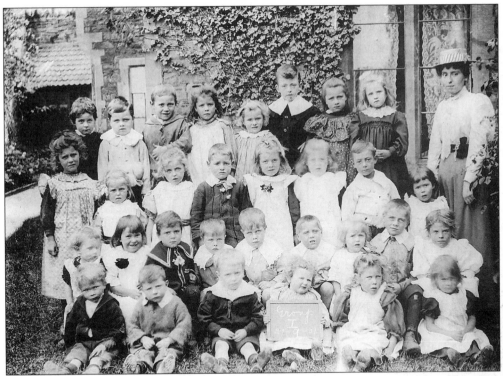

Infants' class at St Luke's Church School, 27 September 1901.

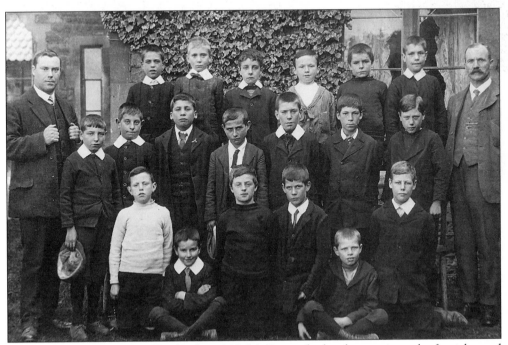

Boys' class, St Luke's Church School, c.1912. Mr Porter the headmaster is on the far right, and also pictured is Mr Ted Dodge, a well-remembered teacher who gave 35 years' service to the school (1907-42) retiring only months before it closed.

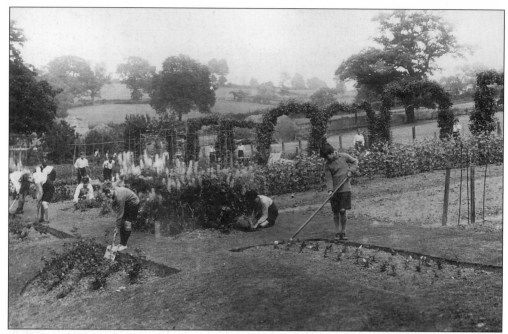

Pupils working in the Church School gardens with the fields around Victory Park in the background. The gardens were set up c.1911 and were strictly for boys only!

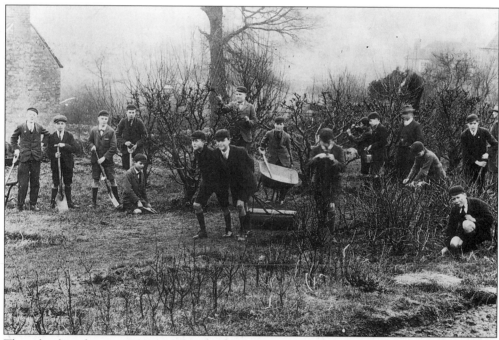

The school gardens in 1926, looking towards School Road. The cottage on the far left is now No 112, on the corner of Jean Road. The gardens flourished right up until the closure of the school in 1942.

70

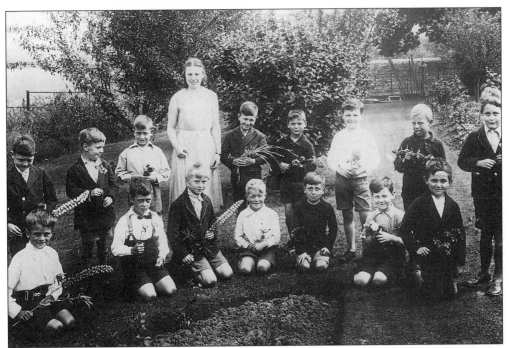

The school gardens, c.1932. The teacher is Miss Cornish. The boys show varying degrees of embarrassment being photographed each holding a lupin or other flower.

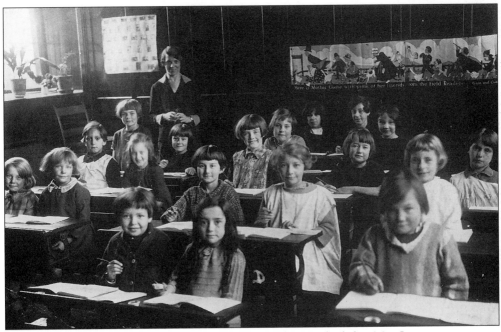

Girls' class, St Luke's Church School, 1927. The teacher on the left is Miss Lugg.

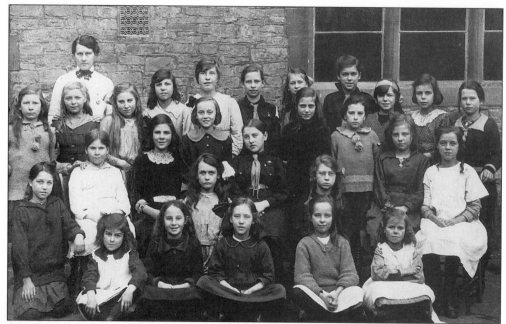

Girls' class, St Luke's Church School, c.1920. Miss Edith Sutton, girls' headmistress from 1918 to 1921 is on the far left; she set up St Luke's Girl Guides in 1918.

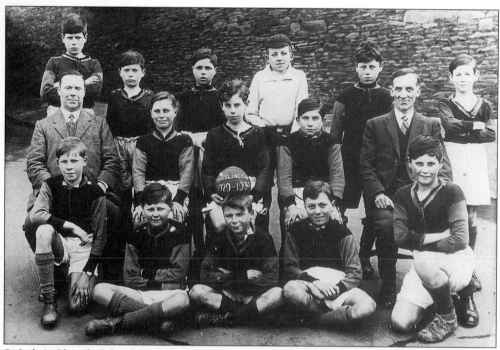

St Luke's Church School football team, 1929-30 season. Mr Ted Dodge is on the left with Mr Francis Marsh, headmaster here from 1924 to 1941 on the right.

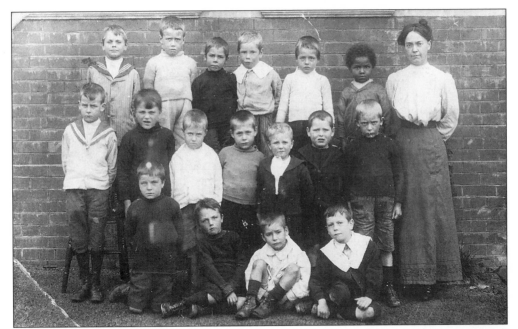

Hollywood Road Council School Infants' class, c.1913. Miss Emma Martin, on the right, (after 1922 Mrs Higgins) was the first headmistress (1913-33). The school became Holymead Infants in 1962.

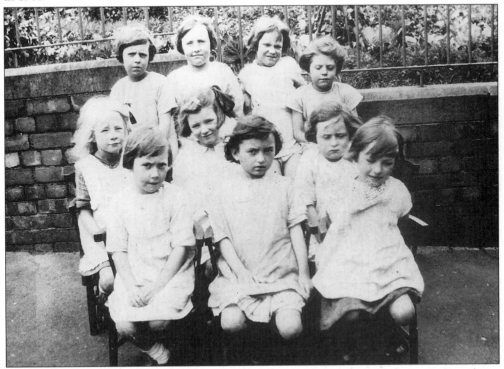

Hollywood Road Infants, 1928. From left to right, back row: Doreen Salter, Irene Gunningham, B. Stratford. Middle row: Audrey Thomas, Mary Webb, Beryl Singer. Front row: Gladys Perrett, Elsie Veal, Audrey Hand.

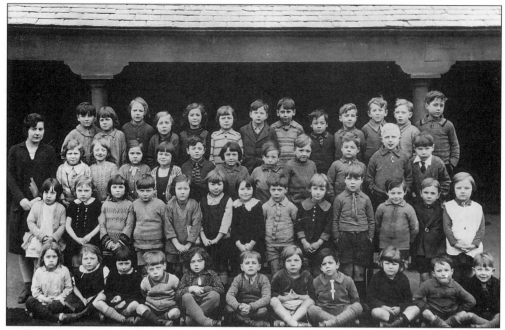

Wick Road Infants, c.1929, with Miss Chapman on the far left. Wick Road Schools, now Holymead Juniors, opened in 1905.

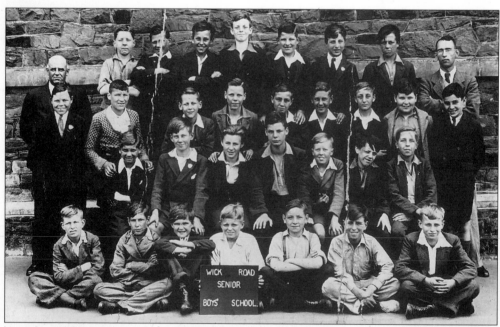

Wick Road Senior Boys' School in 1933. Mr Crandon, the headmaster, can be seen far left with Mr Salmon, teacher, far right.

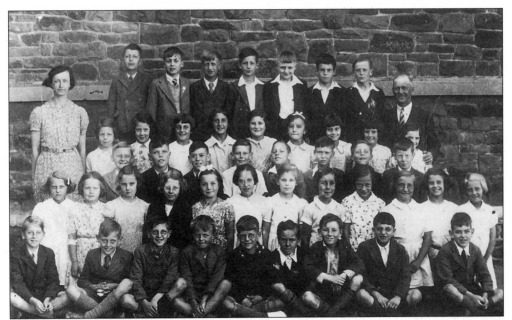

Wick Road School, c.1938. Miss Juniper is on the left and Mr Pearce, the headmaster, on the right.

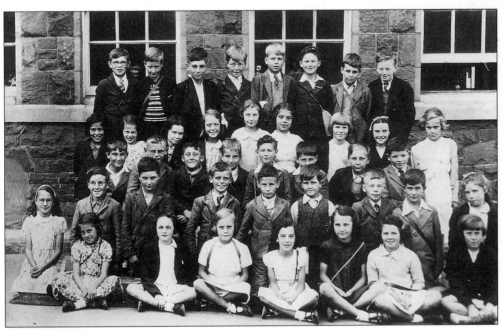

Wick Road School, c.1940. Note the gas mask cases.

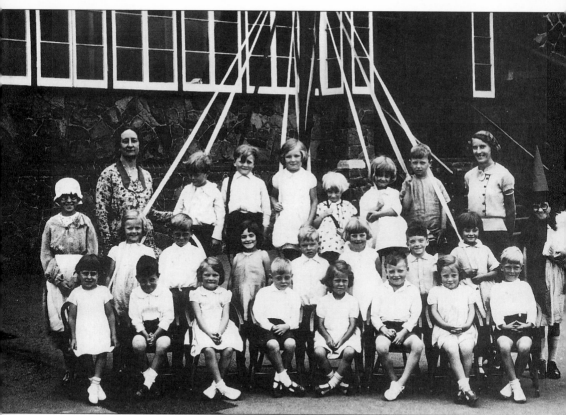

St Anne's Junior Schools (opened in 1900), on the corner of Langton Road and Bloomfield Road, 1900s. Dame Eva Turner, the famous opera singer (1892-1990) was once a pupil here when she lived in Arlington Road and later Newbridge Road.

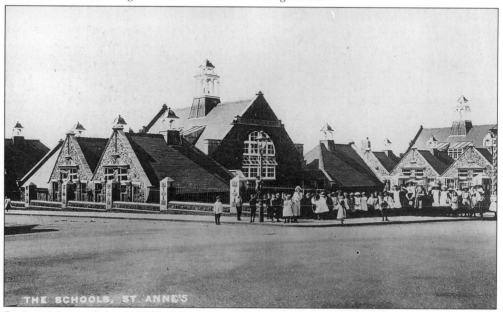

THE SCHOOLS, ST ANNE'S

St Anne's Junior School, 1930s. Miss May, the headmistress, is on the left.

## Five

# Brislington at Work

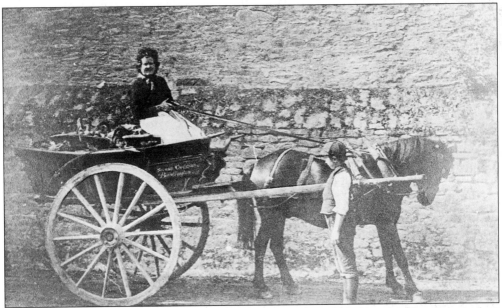

Mrs Susan Coggins (1819-1907) of Rock House, The Rock, c.1870. Susan and her sister-in-law, Sarah (1826-1902) started the Coggins family market gardening business in the 1860s. The family had been in Brislington since the 1740s and eventually came to possess all the property in The Rock, as well as other cottages and houses in School Road, Church Hill and Church Row. They continued to own much of The Rock until the early 1970s. The market gardening business was continued by George Coggins (1891-1962) and his second cousin Tom (1892-1956) until the 1960s. Produce was sold at markets in Bristol and Keynsham as well as by horse and cart in Brislington and Knowle, including supplying the Sandy Park shops.

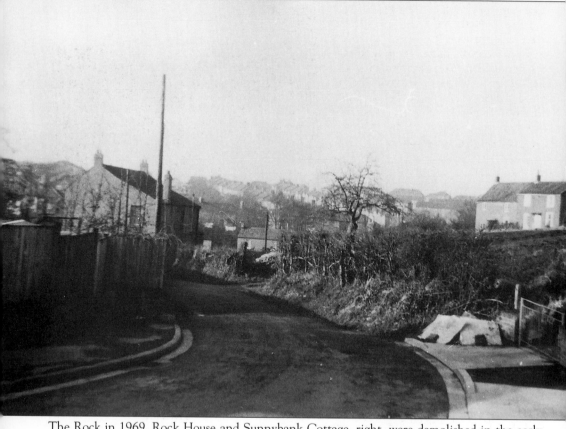

The Rock in 1969. Rock House and Sunnybank Cottage, right, were demolished in the early 1970s to build Millbank Close. Rock Villa (built c.1870) was bombed on 6 December 1940. Thirteen of the eighteen people sheltering in the cellar were killed, including five members of the Coggins family. The house was rebuilt in the late 1940s but was demolished in the early 1970s; Nos 26, 24 and 22 The Rock now stand on the site. The entrance gate posts and part of a boundary wall survive.

The garden of Rock Villa in 1940, looking across the fields to School Road. Gertie Coggins, back left (died c.1980), wife of George Coggins, was injured in the air raid, but her sister-in-law Babs, back right, was killed. Mrs Emma Jane Coggins, seated centre (1865-1951) also survived. Seated on the left is Mrs Allsop (Gertie's cousin) with her daughter Muriel on the right. George Coggins' dog 'Nigger' can be seen extreme right.

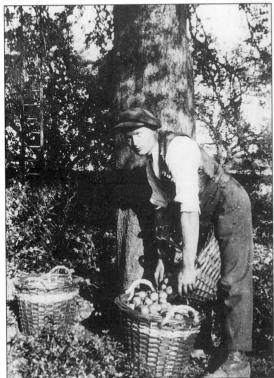

Tom Coggins (1892-1956), grandson of Susan Coggins, picking apples in the orchard at the back of Rock House, 1920s.

79

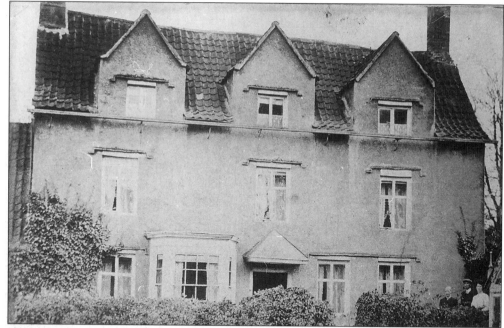

'The Shrubberies' (later known as 'Seven Gables'), c.1910. This was an Elizabethan house where the Biggs family ran their market garden from the 1880s until the 1950s. It was demolished c.1965 and stood behind the present St Luke's Church Hall in Church Parade. The site is now covered by the shops' car park.

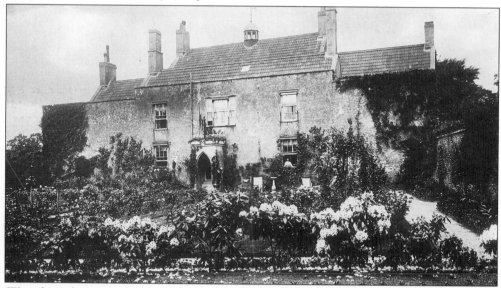

'Winash' in the 1920s. Built in 1750 by John Braikenridge, it was finally owned by Commander Victor Marryat (d. 1927) who had a market garden there from c.1920 until 1937. He was the great-nephew of the Victorian novelist Captain Frederick Marryat, author of *Children of the New Forest* (1847) and many other books. The business was continued for some years by William Manuel, the manager of the market garden who lived in a cottage adjoining the house that was demolished c.1960 to make way for the Dixon Road area of Brislington Trading Estate. Note the bell cupola on the roof.

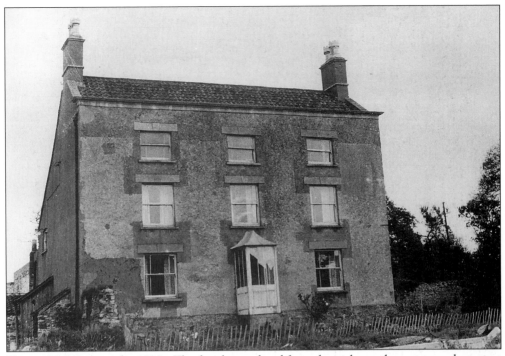

Flowers Hill Farm in the 1930s. The farmhouse dated from the eighteenth century and was part of the Clayfield-Ireland estate. It was demolished in 1964 to build the Hungerford Road Community Centre.

BRISLINGTON'S FARMS

At the turn of the century there were 16 working farms in Brislington, mostly dairy concerns, as well as several market gardens and small holdings. Today only five farmhouses still survive and there is only one working farm. Apart from those referred to and illustrated, the others were: Scotland House Farm and Scotland Bottom Farm in Stockwood Lane (the latter now demolished), Cherry Orchard Farm which stood on the junction of Stockwood Lane and Hungerford Road, and Wick Farm which was demolished to build Wick Road Schools in 1905 (now Holymead Junior). The Black Castle (Arno's Castle) was also a farm for many years in the late nineteenth century. There were about a dozen dairy rounds in Brislington early this century, some run from the farms already mentioned and others based in shops and private houses, including: G.S. Morris & Son (No 2 Sandown Road), Daniels (No 1 Bloomfield Road), Padfields (No 12 Montrose Park), Gosling's (No 14 Bellevue Park), Broderick's (No 3 Manworthy Road), Miller's ('Springfield Dairy' in Water Lane) and Ford's, Baker's and Rex's (No 10 Sandy Park Road).

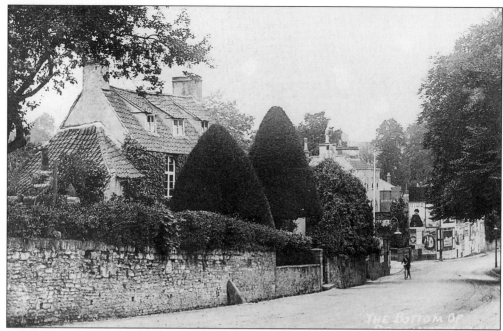

Linton Farm, Brislington Hill, 1920s. Farmed by Francis Bishop from 1883 until his death in 1903, it was taken over by his son-in-law Tom Fuller who operated the largest dairy round in the village. The farm was Clayfield-Ireland property and the Fullers left in 1925 when the estate was broken up. The house was demolished c.1936; it stood at the entrance to Runnymead Avenue.

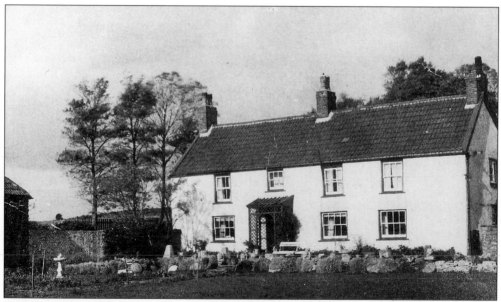

Emery's Farm, 1930s. Dating from the seventeenth century, the name was a corruption of 'Amory's', a Thomas Amory being the occupier around 1640. It was later part of the Gore-Langton estate and was last occupied by the Fuller family from 1931 to 1967, where Tom Fuller's daughters, Winnie and Margaret, ran a poultry farm. It was demolished in 1967 to build houses in Condover Road off Broomhill Road. The name is perpetuated in Emery Road.

Members of the Bishop and Fuller families at Linton Farm in the early 1900s. Francis Bishop is pictured in the cart on the right, his daughter Annie Kate, on the left holding a dog and his son-in-law, Tom Fuller in the centre.

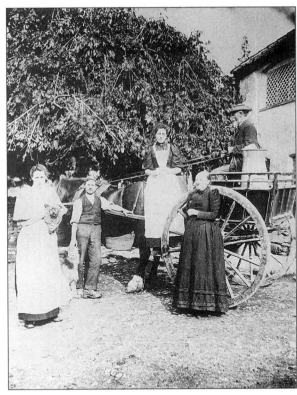

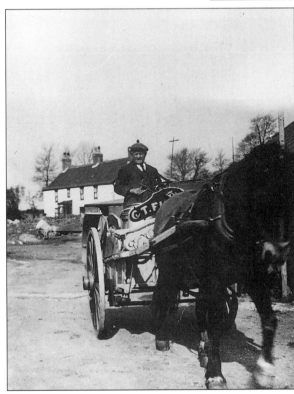

Tom Fuller (1867-1937) starting off on his dairy round from Emery's Farm with Philip the horse, 1930s.

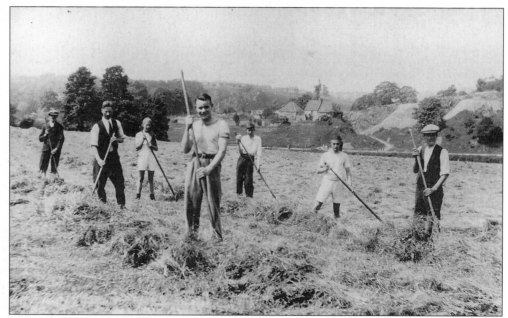

Haymaking at Eastwood Farm, seen in the centre distance, 1930s. This seventeenth century farmhouse still stands, now off Wyndham Crescent, Broomhill. It was part of the Clayfield-Ireland estate and was owned by the Armstrong Trust until 1959, and was the last working dairy farm in Brislington. Arthur Heal (1900-1993), who was the last farmer there from 1928 to 1959, is pictured second from the left.

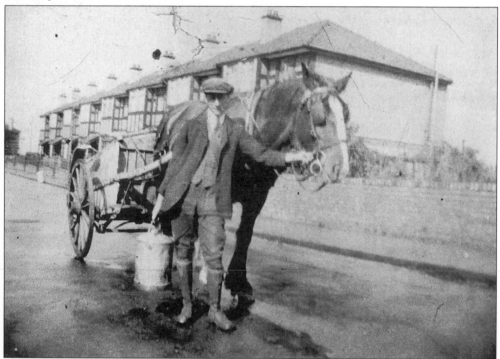

Arthur Heal on his dairy round with Smart the horse in Braikenridge Road, St Anne's, late 1920s.

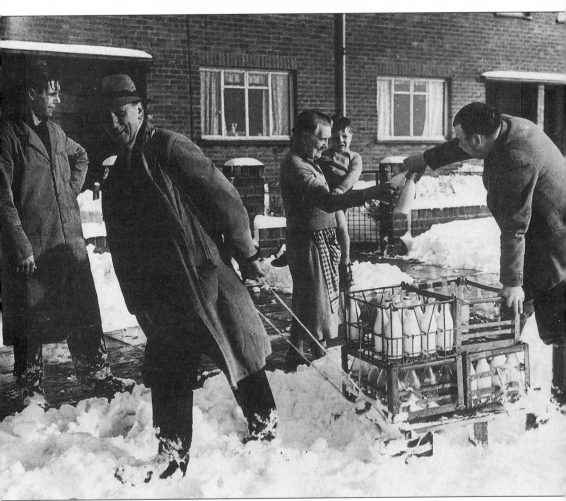

Arthur Heal delivering milk by sledge in Allison Road during the winter of 1963. Mr Heal carried on his business after leaving Eastwood Farm moving to No 14 Bellevue Park (formerly Gosling's Dairy); he continued to serve customers until the tragic death in 1981 of his son Mike, seen here on the far right.

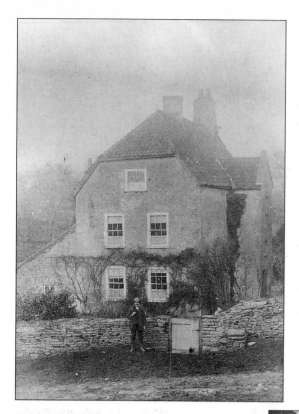

Oakenhill Farm (now off Bonville Road), c.1910. This is Brislington's oldest surviving farmhouse and was first referred to in 1586. Ted Brean (seen here) rented the farm from the Clayfield-Irelands with his brother Tom between c.1900 and 1925; they lived, however, at Woodbine Farm in Water Lane (see below).

Ted Brean at Woodbine Farm, Water Lane, 1900s. Ted and his brother were the last occupiers and were farmers and coal hauliers, keeping geese, turkeys, cattle and sheep. The farmhouse was demolished in 1938 to build houses in Gotley Road.

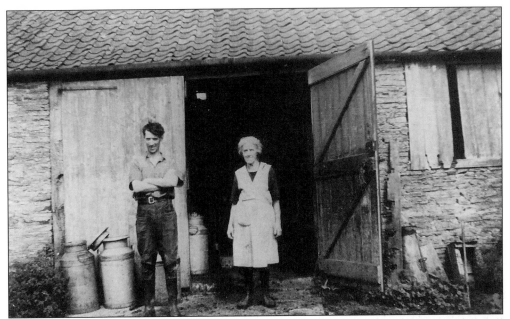

Gordon Carey (b. 1915) and his mother Mrs Alice Carey outside the cowsheds at Oakenhill Farm which still survive today, c.1945. The Carey family ran a dairy round in the village between c.1925 and 1948, Gordon continuing the business with his mother after the death of his father, Harry in 1940. They lived in The Square in Brislington village and were the last family to farm at Oakenhill from c.1928 to 1951. Mrs Carey died in 1955 (see also p. 120).

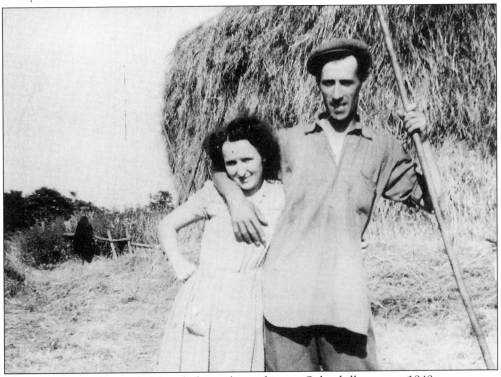

Gordon Carey and his wife, Muriel, during haymaking at Oakenhill, summer 1949.

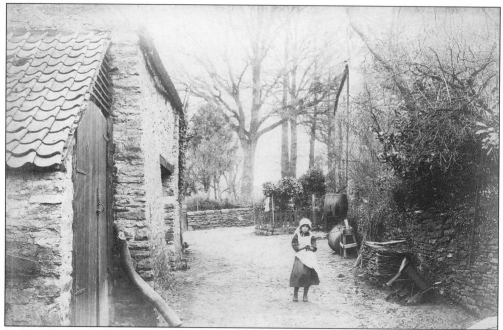

Doncaster Farm, c.1880. It was farmed by the Waymouth family from c.1700 until about 1934. The final occupiers were the Sutors (c.1936-c.1941). The building was twice badly damaged in wartime air raids and was later used for munitions storage. It stood near the site of the Bristol Fan Co. Ltd in Broomhill Road and was demolished c.1950.

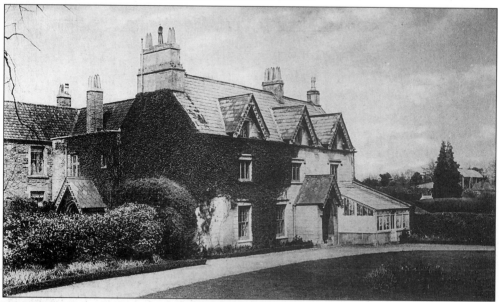

Heath Farm (now Heathcourt Restaurant), Ironmould Lane, c.1906. Built in the seventeenth century with later nineteenth century additions, it was originally part of the estate of the Bridges family of Keynsham. It passed to their descendant – the 2nd Duke of Buckingham and Chandos – who sold it to the Fox family c.1840 after which it became the estate farm supplying farm and dairy produce to the Brislington House asylum. John Reynolds of Reynolds Bros., later had a nursery there from c.1950 to c.1978 and this still exists at the rear of the house.

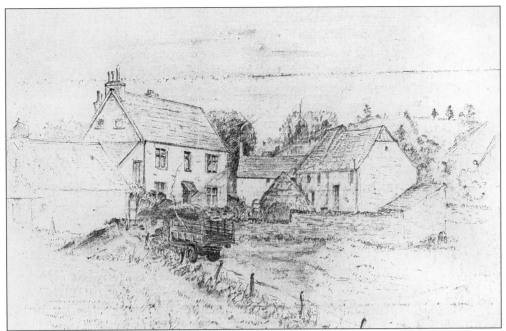

West Town Farm, West Town Lane, 1947. Dating from c.1800, this became part of the Clayfield-Ireland estate and was farmed by the Hassell family from c.1820 until 1925, when it was taken over by Albert Clark, the final occupier. It was demolished in 1953 to build West Town Lane Junior School and some of the stone from the house was incorporated in the façade of the school entrance.

St Anne's Farm, shortly before demolition in 1937 to build houses in Wootton Road. St Anne's Board Mills is in the background.

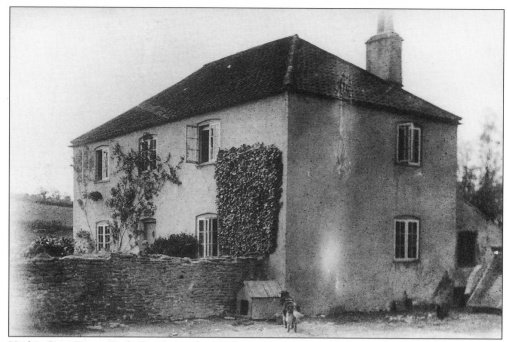

Hick's Gate Farm, Bath Road, on the Brislington-Keynsham border, 1900s. It survives today with cattle continuing to be grazed in the surrounding fields, and a farm shop is run from a nearby cottage. Part of the Cooke-Hurle estate until 1946, it was occupied by the Miller family from c.1904 until c.1938.

The Woodpile, near Hick's Gate, 1928. From left to right: Fred Miller (Harrow Road), his brother Charles who lived in the farmhouse, Henry Bennett who lived in Hick's Gate Cottage, and his son John. There was a large orchard, cattle and poultry were kept, and the fields stretched towards Stockwood.

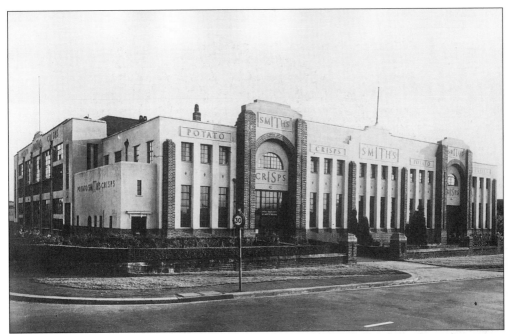

Smith's Crisps Factory, Bath Road. Built in the company's individual style and opened in 1936, it closed in 1966 and became Radio Rentals. It was demolished in 1988 with the exception of a small section near an old mine shaft; the site is currently awaiting redevelopment.

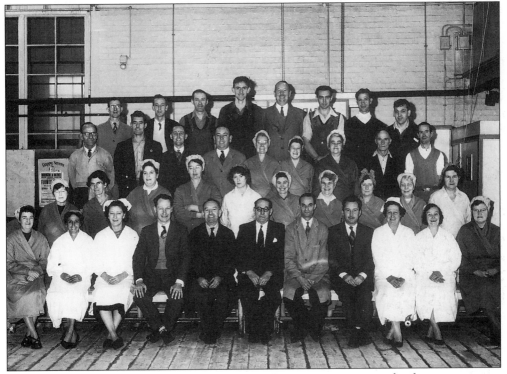

Staff at the Smith's Crisps Factory, 1959. Mr B. Joyce, manager, is in the front row centre, wearing glasses.

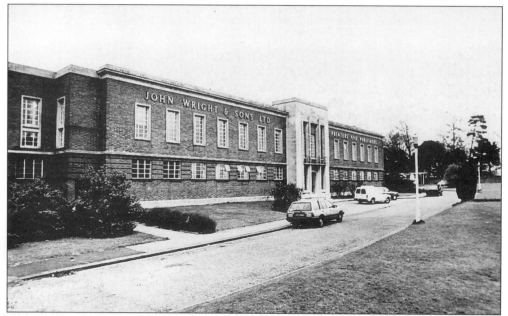

John Wright & Sons Ltd, Bath Road. Opened in 1948, it was the first post-war 'factory' on the main Bath Road. Founded in 1825, Wright & Sons was one of Bristol's oldest printing firms and had a high reputation for printing medical books. After closing in 1986 the building was demolished. A McDonalds 'drive-thru' restaurant was built here in 1992.

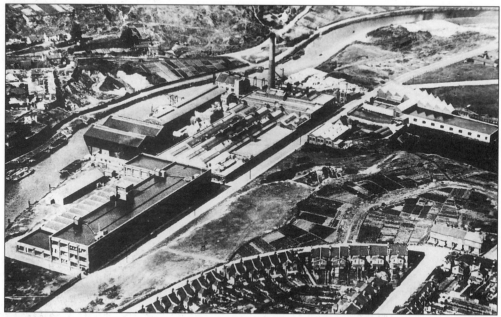

Aerial view of St Anne's Board Mills, 1930s. Building near the ancient site of St Anne's Chapel-in-the-Wood began in 1914 and eventually covered a hundred acres. By 1958, 100,000 tons of packaging a year was being produced by a workforce of 1,800. The mills finally closed in 1980 and in 1984 the last of the 100-foot high chimneys that had dominated the skyline for over sixty years was demolished. By 1992 the site had been cleared and the present development of houses and shops began.

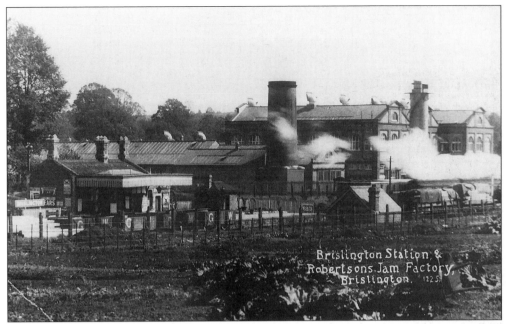

Brislington railway station and Robertson's Jam Factory, 1920s. The 'Golden Shred' works of James Robertson & Sons opened in 1914 and was described as situated 'in charming countryside'. It was a model factory in its day and by the 1960s it had also become the largest jam factory in Europe. Generations of local people, mainly women, worked 'down the jam factory' producing jams, mincemeat and the famous 'Golden Shred' marmalade. It closed in 1980 and was demolished to build the present Tesco Superstore, opened in 1985.

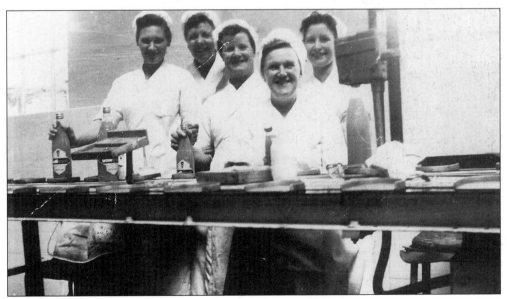

Staff at Robertson's in the 1960s, making 'Gollicrush' orange squash.

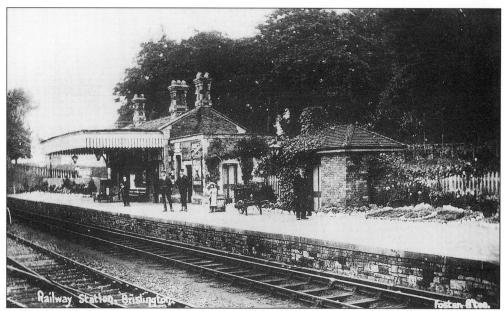

Brislington railway station, 1900s. It was opened in 1873 on the Bristol and North Somerset line to Radstock. It was closed to passengers in 1959 and to freight in 1963. The line closed completely in 1968. The main station building, however, still stands off Talbot Road.

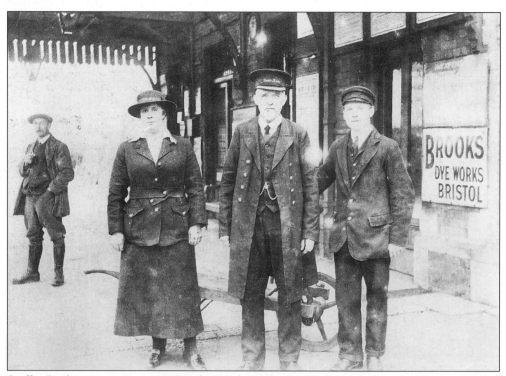

Staff at Brislington station, c.1917. John Royle Williams, the first station-master (1873-1920) is pictured in the centre; Harold Hole, a trainee porter is on the right and Mrs Swaine, who, as Mr Hole remembers, 'did all the heavy work', is on the left.

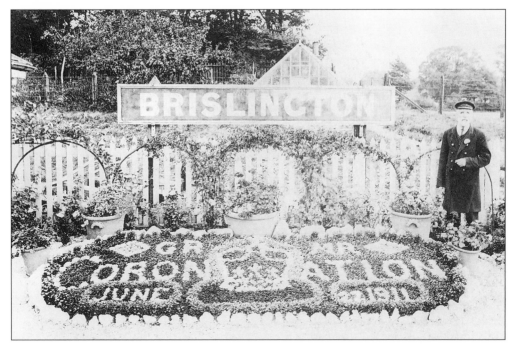

Brislington station garden planted out for the coronation of George V in 1911. The station became well known for its beautiful garden that won first or second prize in the GWR (Bristol Division) annual Best Station Garden Competition for over thirty years, thanks mainly to the efforts of stationmaster, J.R. Williams, pictured right.

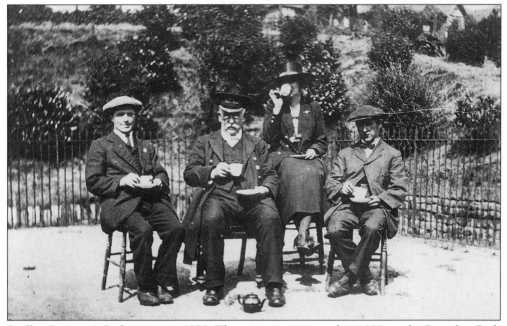

Staff at St Anne's Park station, c.1920. The station was opened in 1898 on the Bristol to Bath GWR line that had come into operation in 1840. The station closed in 1970. Aristarchis Murrow, centre, was the original stationmaster (1898-1920). Houses in First Avenue can be seen in the background.

Charles Adlam (1834-1906), coal merchant of Vine House (also known as 'Mount Pleasant') in Grove Road and his wife Caroline, c.1900. Mr Adlam came from Wiltshire and helped build the Brislington to Pensford railway line. Although he could not read or write, he ran his coal business from the side of the shop from the 1870s until his death, supplying the local gentry and Brislington House Asylum. He also helped to build the Wesleyan Chapel in The Square in 1885 and was one of those who laid the foundation stone.

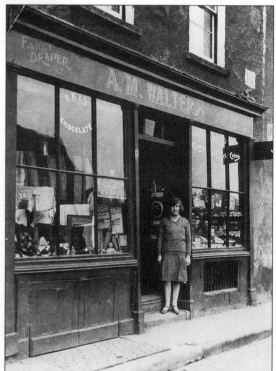

Miss May Walters (later Mrs Smart), granddaughter of Charles Adlam, outside Vine House in 1930 where she ran a tobacconist's, drapery store and sweetshop from 1928 to 1956.

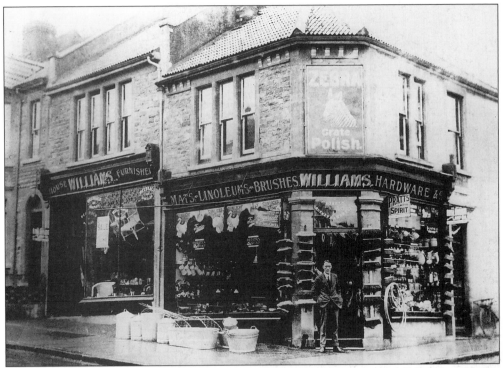

Mr Owen Williams, c.1923, outside the hardware and ironmonger's shop he founded at Nos 81-83 Sandy Park Road in 1913. It still survives today as the oldest shop in the road.

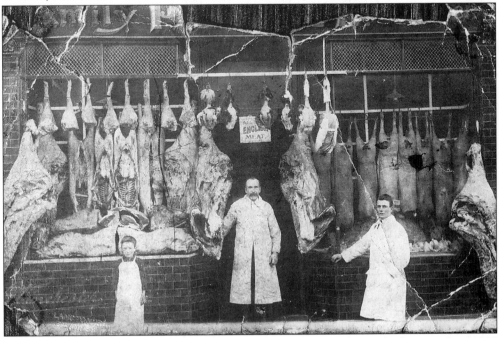

Powell's butcher's shop, No 65 Sandy Park Road, c.1920. The family ran the business from 1910 to 1948 and it is still a butcher's today. Charles Powell is pictured (centre) with sons Jack (left) and George Baden Powell who inherited the business (right).

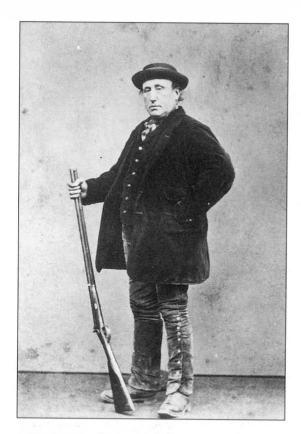

Richard Nicholls who came from Rampisham in Dorset in 1853 to be gamekeeper to 'Squire' Ireland. He lived at Keepers Cottage (see p. 16) until c.1878 when he retired to No 4 Bellevue Road, one of Brislington's new 'town houses'. In 1860 he was also recorded as a parish constable.

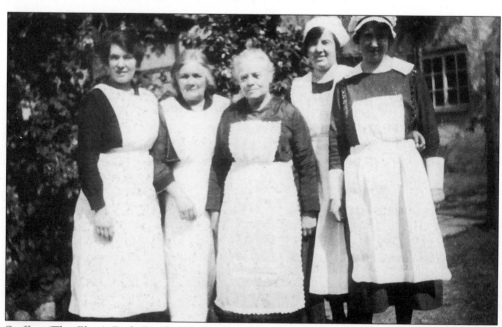

Staff at 'The Elms', Bath Road, 1925 (see p. 35). The Spear family lived at 'The Elms' and Fanny Murliss, centre, was their nanny for many years.

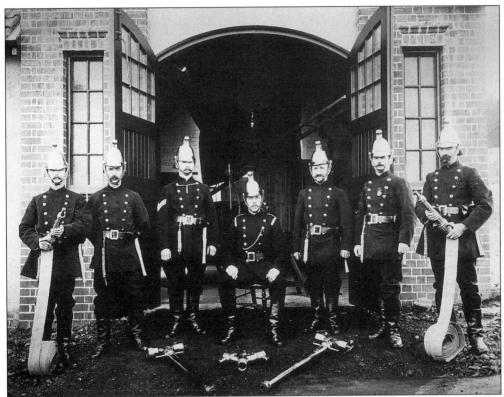

Brislington Volunteer Fire Brigade in 1912, outside the newly built station in Hollywood Road. The building still stands today. From left to right: R.J. Brewer, F. Evans, A. Bowden, J. Veal (captain), H. Mogford, A.C. Beacham, C. Abbot.

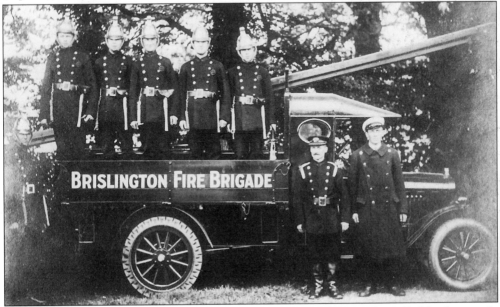

Brislington Fire Brigade, c.1926. From left to right: F. Knight, B. Watts, R. Henderson, A. Knight, L. Minner, G. Norley, T. Miller, A. Sobey (driver).

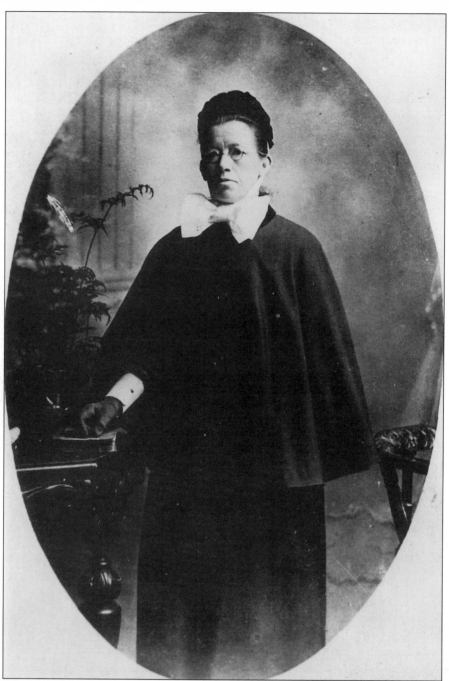

Nurse Emma Atkins (1856-1929), c.1910. A village nurse and midwife from the 1890s until the 1920s, she claimed to have brought more than a thousand babies into the world during her forty years' service in Brislington. She could be rather severe but was much loved and a great friend to everyone. Though without any formal training, she was nevertheless the first person everyone went to for medical help. She lived first at what is now No 25 Hollywood Road, and later at No 19 Montrose Park. In later years she was assisted in her work by her daughter Caroline.

Dr Alexander Cochran of No 479 Bath Road. He was Brislington's first resident doctor from 1902 until his death c.1925.

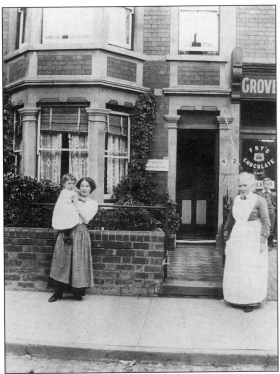

Mrs Sarah Petty on right was also a nurse and midwife in Brislington in the 1900s and 1910s; she lived at No 4 Grove Park Road. Mrs Harris and her son Ray, on left, lived at No 6. Gilbert's Dairy and Grocers was at No 2, on the far right.

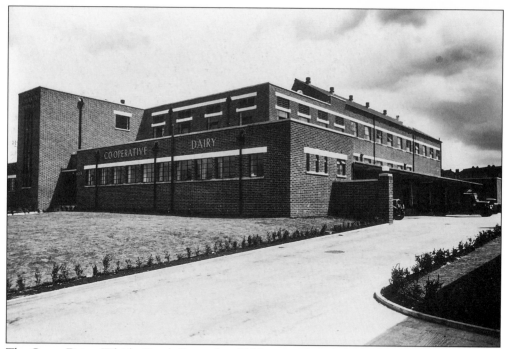

The Co-op Dairy, Whitby Road. Opened in 1938, it was demolished in 1995.

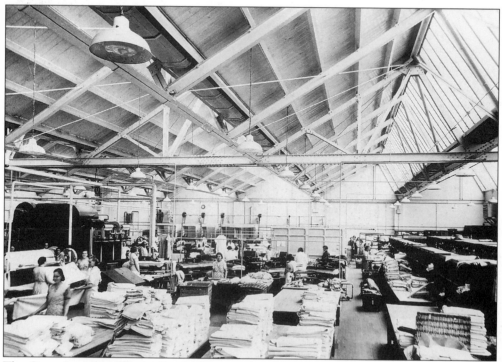

The Co-op Laundry, Whitby Road. This was also opened in 1938. It closed in the late 1960s and the building is now demolished.

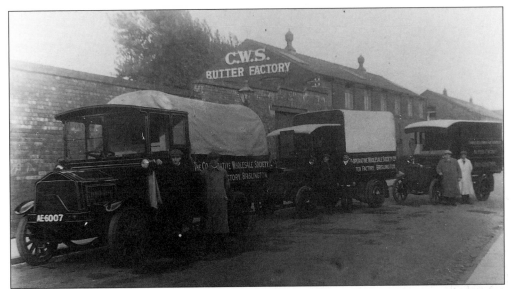

CWS Butter Factory, Whitby Road, c.1920. Opened in 1904, this was Brislington's first factory and the oldest CWS butter factory in the country. In the 1950s 250 tons of butter a week were produced, including the 'Friary' and 'Avondale' brands as well as Brislington's own 'Mayflower' blend. By the health conscious 1980s, however, the public were fast losing their taste for butter and the factory closed in 1986 and was demolished two years later.

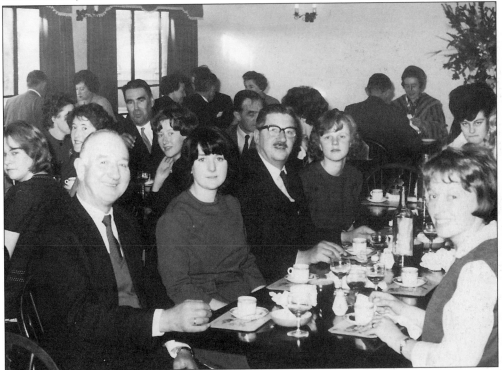

CWS Butter Factory staff dinner at the Little Thatch Restaurant, Whitchurch, 1960s. Mr Maurice Jefferis (centre, wearing glasses) was an employee from 1922 until 1972, becoming resident manager in 1958, and retiring as deputy group manager.

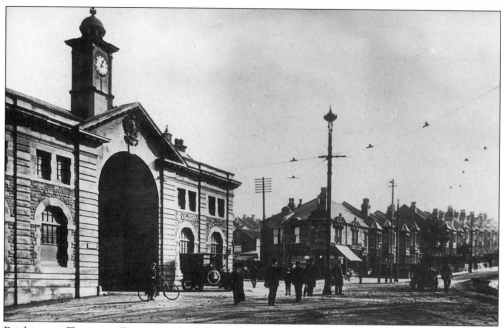

Brislington Tramway Depot, Bath Road, 1900s. Built in 1898-9, the line was extended to Brislington village in 1900. The last tram ran from the village to the depot in September 1938. The building is now Avon County Transport Depot.

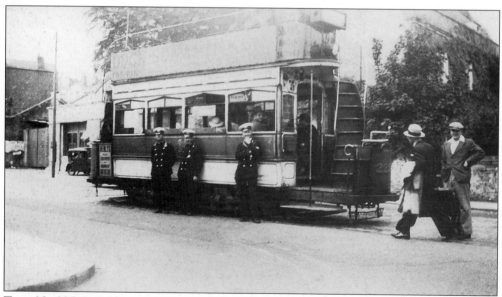

Tram No 225 in Brislington Village, 1930s. Wisteria House, on the right, was demolished in 1939. Bridge Garage, on the left, operated from 1926 until 1939. Badger's Walk Flats were built on the site in 1983.

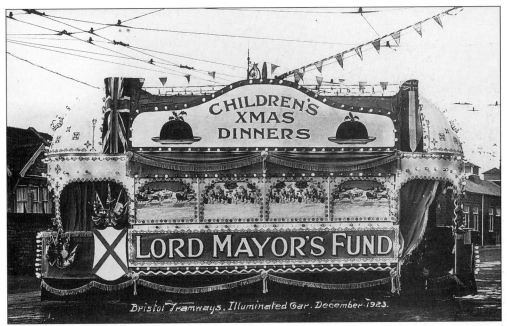

Brislington Tramway Depot in 1923. The illuminated tramcars were very much a feature of Christmases in the 1920s. They raised money for the Lord Mayor of Bristol's Christmas Dinner Fund for needy children. Bloomfield Road is visible on the far left.

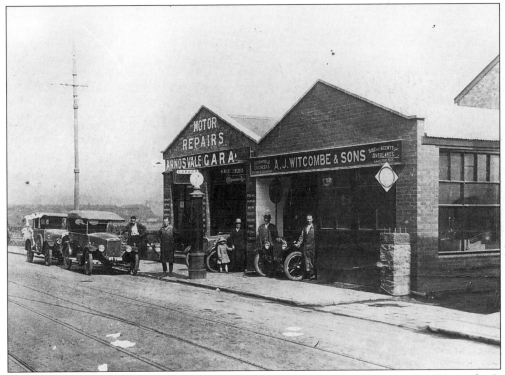

Brislington's first petrol pump, Arno's Vale Garage, Bath Road, 1922. Run by A.J. Witcombe & Sons until the early 1930s, it is now the site of a wine warehouse.

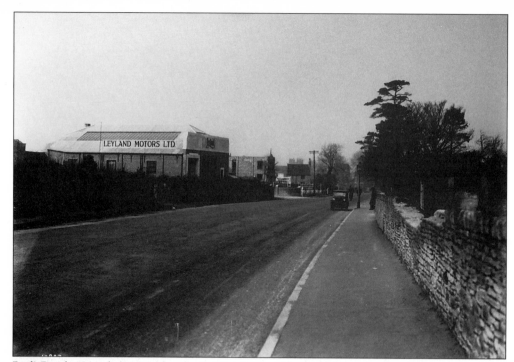

Bath Road, 1931 showing a developing Brislington Trading Estate. Leyland Motors (now City Tyres) is on the left and Southfield Cottage, centre background. Rose Cottage stood off right, behind the wall. After Crittall's Windows (1927), others businesses followed to the estate before 1939: Trist Draper (1930), the building being designed by Albert Thomas, a pupil of Sir Edward Lutyens; Leyland Motors Ltd (1931); Smith's Crisps (1936); and Coca Cola (1939). In 1948 John Wright & Sons (est. 1825) built the first post-war factory on the main road and others, including Modern Engineering (1952); Bryan Bros. (1959); Bristol Fan Co. Ltd (1960), Schweppes, and Lyons Bakery formed part of the thriving estate that extended along Clothier, Emery, Dixon and Broomhill roads and Hulbert Close. The recession of the early 1980s, however, led to the closure of the most of the major factories leaving many empty properties.

# Six
# Brislington at War

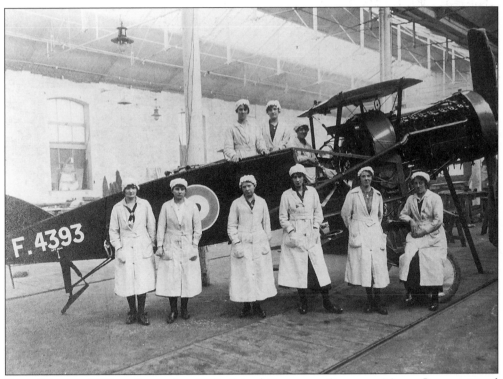

From February 1915 to September 1918, Bristol Tramways Company Motor Constructional Works on Bath Road, had a sub-contract from the Bristol Aeroplane Company. They employed local women and built 6 Bristol Box Kites, 161 Bristol Scout Model Cs, and 24 Coanda TB8 training planes. The works opened in 1912 and became Bristol Commercial Vehicles in 1955, closing in 1983. The MFI and Great Mills superstores, opened in 1986, now occupy the site on Kensington Hill.

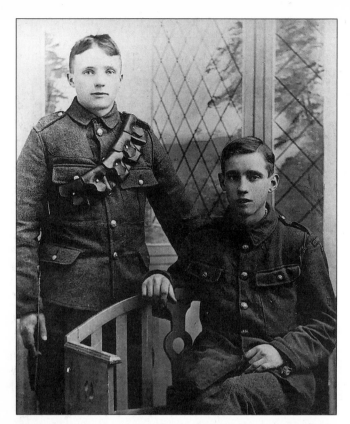

Harry Petty and his brother Charles of No 17 Grove Park Road, c.1915. They both served in the 'Gloucesters': Harry with the cavalry in Egypt, and Charles in France where he was badly wounded. His leg was amputated on his nineteenth birthday and he tragically died a few days later in July 1916. A total of 108 Brislington men did not return from the war and their names are recorded on the memorial in St Luke's Church.

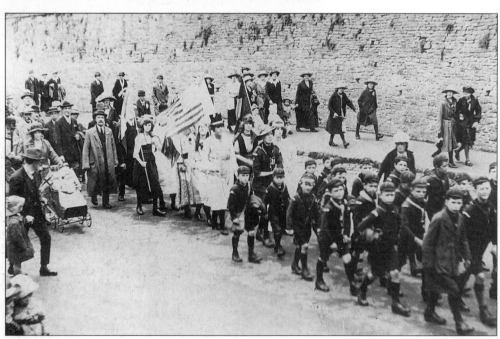

Procession on Brislington Hill en route to the Brislington Peace Day celebrations at Brislington Hall, July 1919.

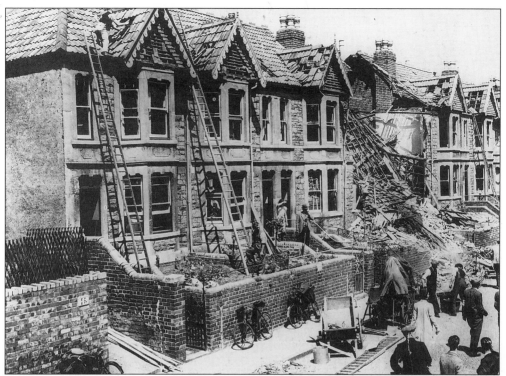

Air raid damage in Grove Park Road, 25 June 1940. Several of the first bombs in Bristol fell on Brislington, also causing damage and casualties in Pendennis Park and Glenarm Walk. Nos 7 and 9 Grove Park Road were completely destroyed and later rebuilt.

The Co-op Bakery in Whitby Road, built 1943-44 and taken over by the US Army as headquarters for American troops stationed in Brislington. The bakery was surrounded by barbed wire and patrolled by armed guards day and night. It is said that thousands of francs were stored there in preparation for D Day. Americans were billeted all over Brislington and a large camp was set up in fields off School Road. The bakery was demolished in 1987.

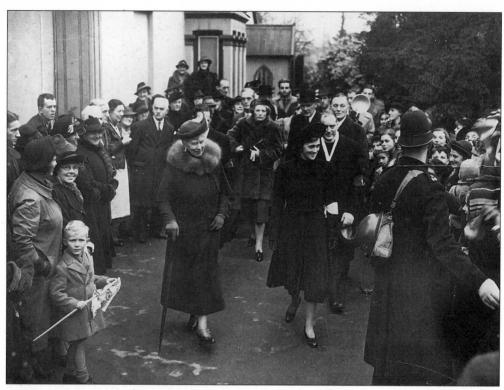

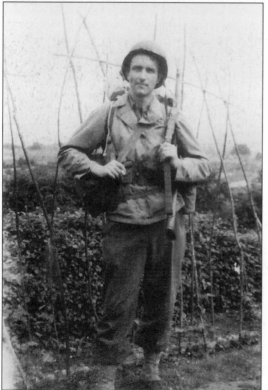

Visit of Queen Mary to the Grove Hall, 16 December 1940. The hall was used as an air raid shelter and rest centre for bombed out families. Queen Mary was accompanied by several other dignitaries including Lady Elles (on the right), the Dean of Bristol (right) and the Duchess of Beaufort (centre). Revd Blythe, the Congregational minister (behind Queen Mary) presented the rest centre staff to the Queen saying: 'these are the workers Ma'am', to which she is reputed to have said, 'Yes, but do they do the work?'

Private Eugene Norton, US Army soldier from Maryland, 1944. He was billeted with the Wilson family at No 133 Allison Road, and is pictured here in the back garden shortly before D Day. Mr Norton lives today in Arizona and wrote his memories of his stay in Brislington in 1989.

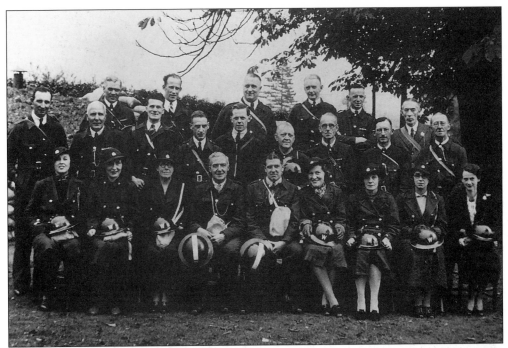

ARP wardens outside Crittall's Window Factory, on the corner of Bath Road and West Town Lane, c.1940. Back row, far left: Mr Hobbs, newsagent of No 4 West Town Lane; far right: Mr Wilfred Barwick, chemist of No 8 West Town Lane. Front row, seated far right: Mrs Audrey Barwick.

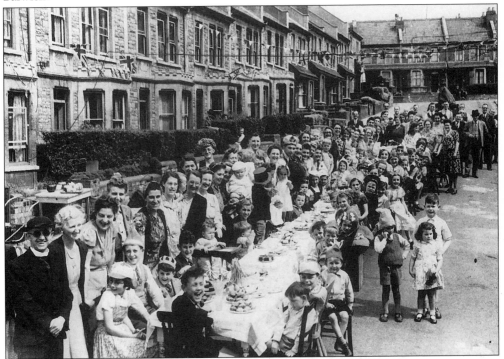

VE Day street party in Sandgate Road, 8 May 1945.

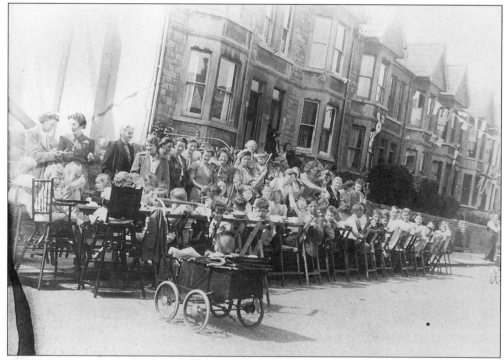

VE Day street party in Grove Park Road, 8 May 1945. Note Nos 7 and 9 on the left awaiting rebuilding after being blitzed in June 1940 (see p. 109).

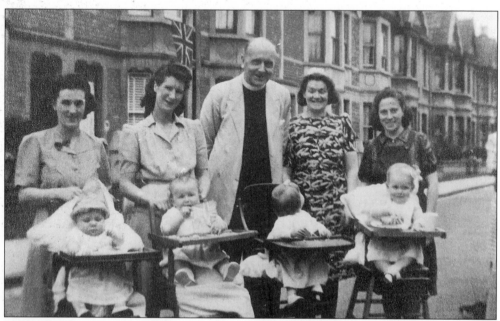

VE Day street party in Repton Road, 8 May 1945. Revd Cecil Symes, centre, was the first vicar of St Cuthbert's from 1929 to 1950, originally at the 'Tin Church' (see p. 64).

# Seven

# Life and Leisure

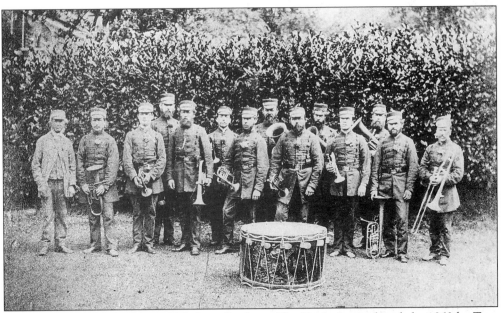

Brislington Village Band, c.1865, believed to be at The Rock. It was founded c.1860 by Tom Weymouth, ninth from left, standing behind the drum. He was the bandmaster and landlord of the Pilgrim Inn. His son, also Tom, took over as bandmaster and as landlord of the Pilgrim in the 1890s, the pub being run by the family for over seventy years. The band, always known locally as "Tom Weymouth's Band" flourished until the 1900s and played at all the local events. Notably, they started the village celebrations for the wedding of the Prince and Princess of Wales in 1863 (later Edward VII and Queen Alexandra) by playing at the top of St Luke's Church tower. They also played at the opening of the Clifton Suspension Bridge and twice weekly at Bristol Zoo. From left to right: 1. Ted Pobjoy, 2. Harry Luxton, 4. Bancock, 6. Joe Russell, 7. Tom Bishop, 8. Eli Cousins, 9, Tom Weymouth, 10. Francis Bishop, 12. Joe Hazell, 13. Ted Nicholls.

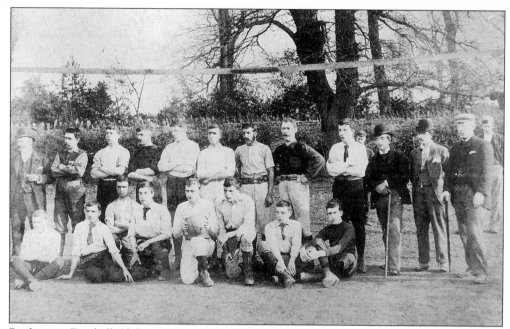

Brislington Football Club, c.1890, probably at Brislington House. Formed in 1887, it survived until the Second World War. Ted Nobbs (1864-1936), centre wearing a dark shirt, was a well known sporting personality of his day, a founder member of Brislington Football Club and Brislington Rifle Club, and a member of the cricket club for 50 years. The present Brislington Football Club was formed in 1956.

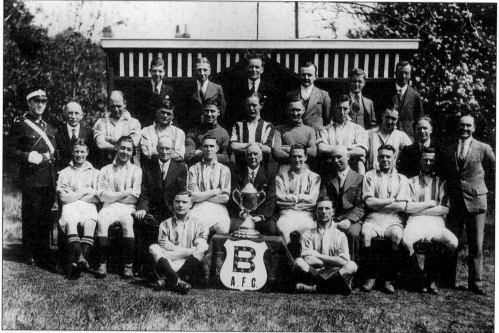

Brislington Football Club, District League Cup winners, 1934-35 season, at their Southfield Lane ground, (now near the Flowers Hill area of Brislington Trading Estate). They played for many years in Holymead Fields, in what is now the Kenneth Road area.

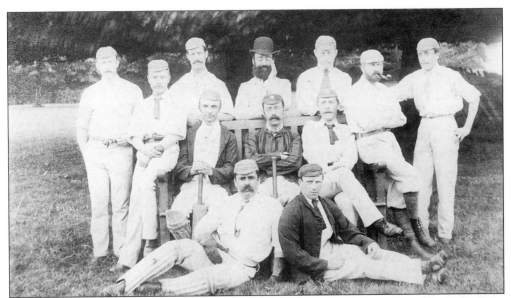

Brislington Cricket Club, 1880s. Founded in 1868, the club played originally on the Brislington House estate, sometimes on Pear Tree Mead near Heath Farm (now Heathcourt Restaurant), and later near 'The Chestnuts' and Cross Post Field (now the site of the 'Park and Ride') before moving to their first ground in West Town Lane in 1909. In 1960 this was sold for house building (the Kew Walk area), and a new clubhouse and ground was built at Ironmould Lane. Dr Bonville Bradley Fox (1852-1902) is seated in the centre wearing a cap and blazer; Ted Nobbs is seated on his left.

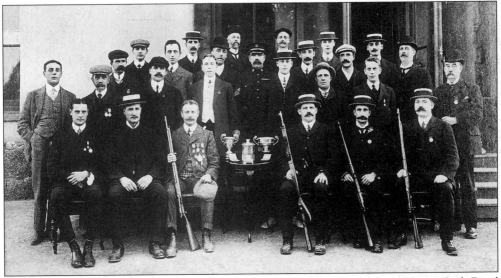

Brislington Rifle Club, 6.45 p.m. Monday 19 June 1911, outside Kensington House, Bath Road (now the site of the PDSA) This was the home of George Lewis Poole (1902-18) who built much of the Kensington Park area and was the club's first president. Formed in 1905, they met at what was then the Drill Hall for the local Somerset Volunteers and which subsequently became the club's headquarters. In 1940 the hall was requisitioned and used by the Home Guard. During this time the club lapsed but was revived in 1947 and continues to flourish today. Sgt. Thomas Jones of Wick Road, centre wearing uniform, was the first Sgt. Instructor.

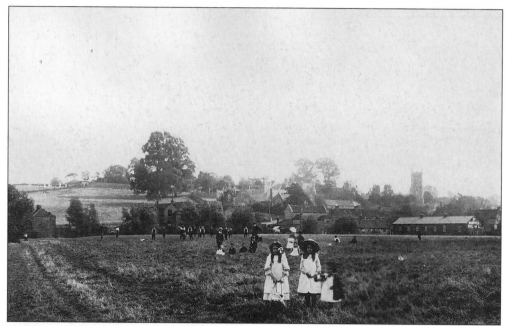

Brislington's first public park, c.1908. Grandly named 'King Edward VII's Pleasure Ground', it opened in 1903 on fields now covered by houses in Jean Road and Clayfield Road. The ground was often waterlogged as it was bounded by Brislington Brook and it was replaced by Victory Park in 1920. No 112 School Road is visible on the far left, Brislington Cemetery above, St Luke's Church School centre, and the Drill Hall (now Brislington Rifle Club Headquarters) on the right.

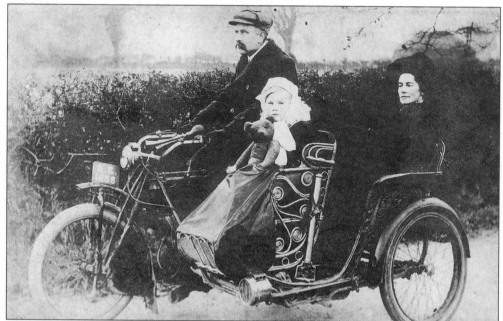

Mr W.F. Leat, builder, plumber and decorator, of Stirling Road, with his wife Bessie and daughter Doreen (later Mrs Hulbert) out for a drive in an early motorbike and sidecar, Stockwood Lane, 1907.

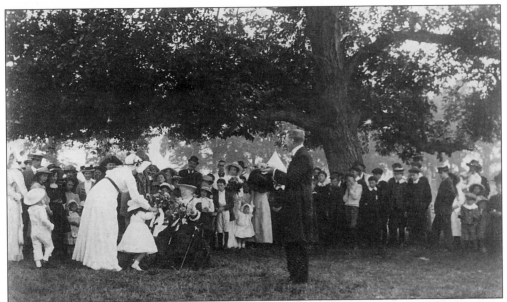

St Luke's Church four-day 'Zumerset Fair' held in fields on Kensington Hill (near the site of the present MFI and Great Mills stores), June 1913. Three-year-old Mary Norris (now Mrs Batty) of Woodland House (see p. 51) presents a bouquet to Dame Emily Smyth of Ashton Court who opened the fair on the last day – 21 June. Revd Alfred Harman, vicar from 1907 to 1918, is standing in the centre holding his hat. The fair raised money to buy the site of the first church hall in Water Lane.

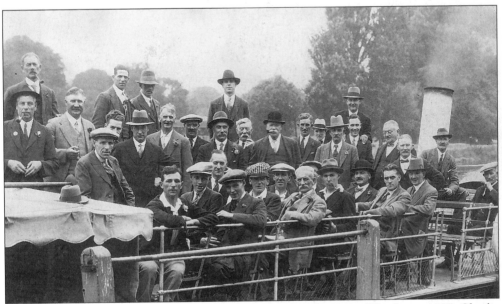

Men's outing from The Pilgrim, Hollywood Road on the Thames at Windsor, c.1927. Charlie Ford, far left in the front row, was a well known footballer. Tom Weymouth, landlord of The Pilgrim is the portly gentleman, on the right, wearing glasses and a bow tie.

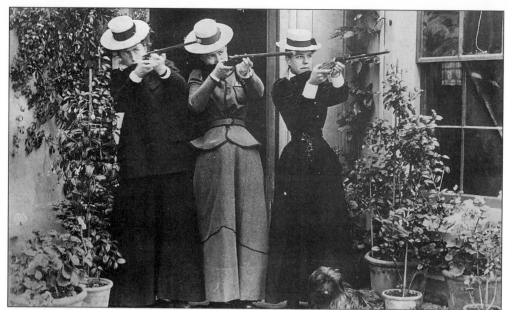

Frances and Emma Vowles of 'The Chestnuts' with Irene Allen of 'The Elms', Bath Road (right) at the front door of 'The Elms', 1890s. Irene was obviously a good advertisement for her father's corset factory! (see p. 35). Who or what these Victorian young ladies were aiming at is not known!

Brislington 'Girl Scouts', 1909, in the garden of Hemplow House, on the corner of Water Lane and Talbot Road (demolished 1969 to make way for the construction of Hawburn Close and Beeches Grove). Brislington had one of the very first guide companies before the Girl Guides were officially formed in 1910. May Jones, far right, was one of hundreds of girls who wrote to Baden Powell suggesting 'girl scouts' groups be formed after he founded the Boy Scout Movement in 1908. From left to right, the other girls are: Marjorie Wells, Doris Spear, Kathleen Bishop, Gwen Spear and Freda Webb. The leader, seated centre, is Miss Beatrice Wise.

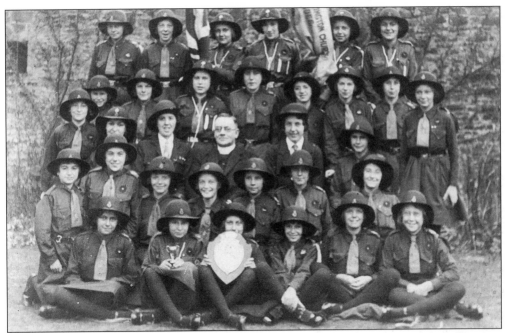

St Luke's 52nd Girl Guides (formed 1918) in the garden of the vicarage, Church Hill House, c.1932. Canon Sydney Worters, vicar of St Luke's from 1922 to 1935 is in the centre.

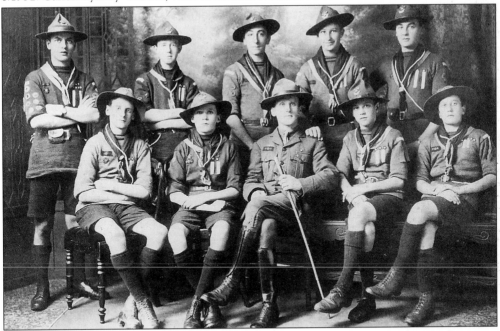

Scoutmaster Percy Johnson with patrol leaders of the 5th Bristol Bonville Scout Troop, c.1918. Dating from 1908, it is one of the few troops in Bristol as old as the movement itself. Mrs Bonville Fox (see p. 44) became their patron in 1913, hence the name. From 1913 they met in the old Congregational Chapel behind the Hollybush Inn before moving to the adjacent hut originally built for Brislington Women's Institute in 1930. They became the 5th Bristol (St Luke's) in 1928 and moved to their present scout hut in Brookside Road in 1962.

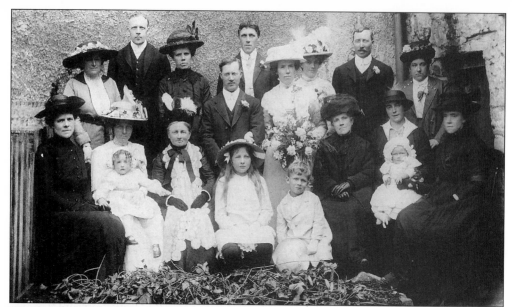

Wedding of Henry Carey and Alice Maud Watts, 10 June 1914, photographed at rear of No 3 The Square (demolished 1969) where they ran 'The Bon Marche' drapery shop and later a dairy. Alice (see p. 87) was parlour maid to the Harmans at St Luke's vicarage between 1907 and 1914. Revd Harman and his wife Enid are on the far left of the back row. Their children Margaret and Lancelot are seated in the centre. Alice was considered a 'village beauty' and local boys used to climb on to the huts at the side of the vicarage to talk to her through her attic bedroom window. One of them fell through the roof!

Table set for the wedding reception of Henry Carey and Alice Watts in an upstairs room at No 3 The Square.

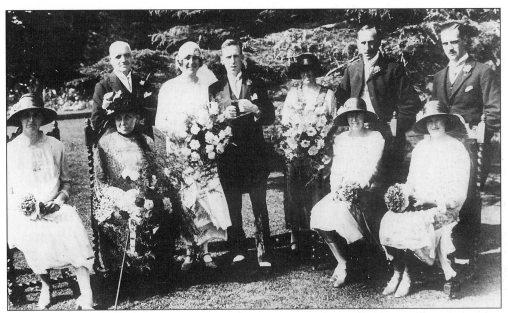

Wedding of Gwen Spear and Donald Gough of Hick's Gate House (see p. 46), 2 September 1925. The reception was held at the bride's parents' home – 'The Elms', Bath Road (see p. 35). From left to right, seated: Doris Spear (bride's sister), Bessie Spear (bride's mother), Marjorie Gough (groom's sister), Heather Jordan (groom's cousin). Standing: Egbert Spear (bride's father), Gwen Spear (bride), Donald Gough (groom), Edith Gough (groom's mother), Harold Gough (groom's father), John Jepps (best man).

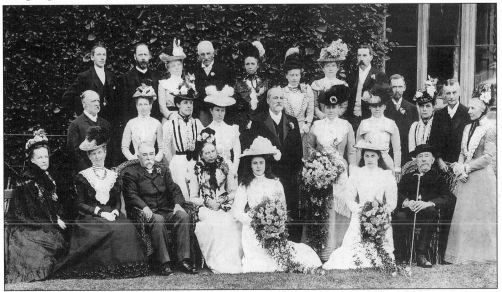

Wedding of Isabella Cartwright, daughter of Revd G.L. Cartwright, resident curate of Brislington 1839-80 (seated front row, on far right), and Major George Rashleigh Edgell, 29 December 1891. The reception was held at the bride's home 'The Hollies', West Town Lane (see p. 50). The event provoked great village rejoicing; there were flags and bunting, a triumphal arch was set up near 'The Hollies', the church bells were rung throughout the day and the 250 schoolchildren were given a treat.

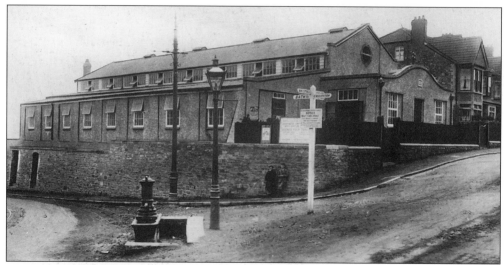

The first St Luke's Church Hall, at the junction of Bristol Hill and Water Lane, 1920s. Opened in 1921, it was used for bazaars, dances and amateur dramatics, the Brislington Players, formed in 1926, being the first local group. It was requisitioned as a mortuary for air raid victims in the Second World War. It closed in 1963 to be replaced by the present church hall the following year. The building was demolished in 1970 and an Exclusive Brethren Hall now stands on the site.

Viscount Weymouth (later 6th Marquess of Bath), at the old church hall after opening St Luke's 'Fancy Fayre', 24 October 1930. Viscount Weymouth was MP for the Frome Division of Somerset, that included Brislington, from 1931 to 1935. The late Mrs Elsie Eden of No 14 Wick Crescent is on the right. Viscount and Viscountess Weymouth returned to Brislington to open another bazaar in 1932.

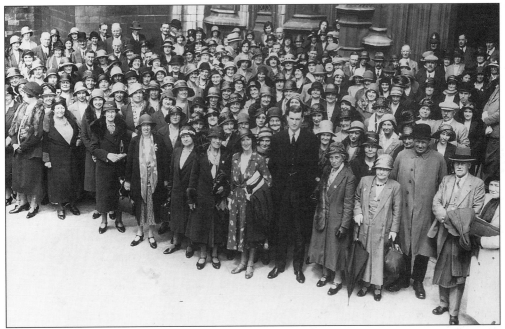

Viscount Weymouth (front centre) with members of Brislington Women's Institute on a visit to the House of Commons, c.1933. Mrs Eden is seen again on the left of Viscount Weymouth. The original afternoon WI branch formed in 1918 closed in 1989, but the evening branch set up in 1971 survives today.

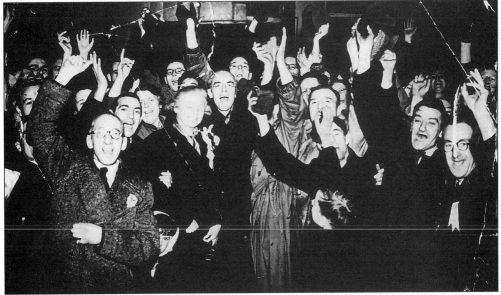

General election night at the Ruskin Hall, Wick Road, March 1950. Sir Stafford Cripps, MP for Bristol East 1931-50, is pictured centre with Lady Cripps. He retired owing to ill health shortly afterwards, having served as President of the Board of Trade and Chancellor of the Exchequer in the post-war Attlee Labour government. Far left, in the background, is the late Alderman Martin, Brislington Labour Councillor for 25 years, who eventually became Lord Mayor of Bristol in 1965-66 after years of being dubbed 'Lord Mayor of Brislington'.

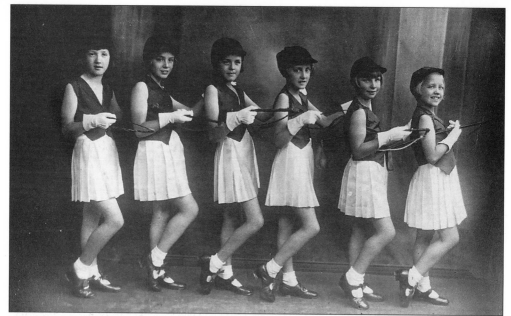

Members of Mrs Lilian Houlden's Dancing School, 1945. From left to right: Barbara White, Rosemary Legg, Mollie Collard, Shirley MacGregor, Hazel Cousins, Pat Powell. Classes were held at the old St Anne's Brotherhood and Sisterhood building, Wick Road (now the Disabled Christian Fellowship). The girls gave regular local shows and during the war performed at the 'Holidays at Home' entertainments held in Victory Park; they also danced at entertainments for American GIs. Mrs Houlden, of No 127 Bloomfield Road, ran the school from the 1930s to the 1970s.

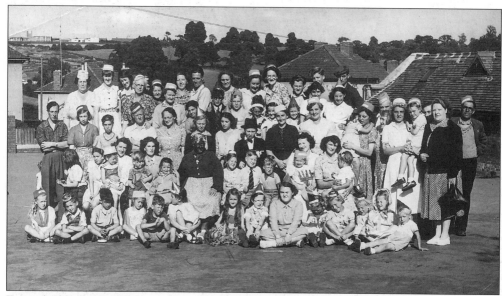

Festival of Britain party for residents of Pendennis Park held in the playground of Hollywood Road School, 28 July 1951. Broomhill Junior School, opened 1951, is on the horizon far left.

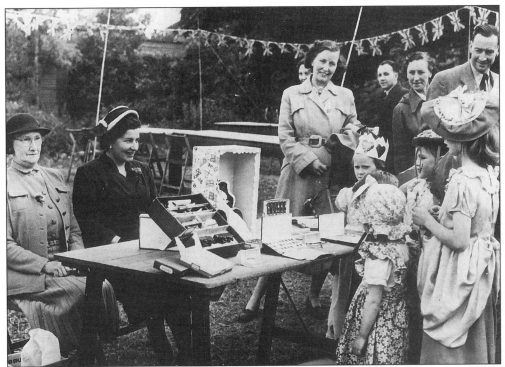

Coronation day party for residents of the Glenarm Road area in the garden of the Gothic lodge, Brislington Hill, 2 June 1953. Mrs Harold Mitchell of Hill Cottage (far left) presents prizes to children in the fancy dress competition; sitting next to her is her daughter-in-law to be, Miss Mary Derrick.

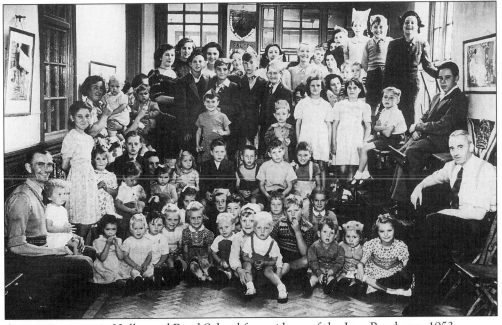

Coronation party in Hollywood Road School for residents of the Jean Road area, 1953.

The Brislington Cinema, Sandy Park Road, on the corner of Belmont Road. Opened in 1913 as 'The Empress', it was one of Bristol's first purpose-built silent cinemas and was run by the Tomkins family (Harry, and later his son George) for most of its life. It was converted to 'talkies' in 1931. It survived two world wars and the Depression, but competition from television and more up-to-date cinemas signalled its closure in December 1956. The building has operated as Brislington Bingo Club since 1962.

The Ritz Cinema, on the corner of Bristol Hill and Warrington Road, c.1970. Hailed as 'The Showpiece of the West', it was officially opened by British film comedian Wally Patch on 8 October 1938, accompanied by the Lord Mayor of Bristol, Alderman J.J. Milton. The event was celebrated by a special showing of *A Yank at Oxford* starring Robert Taylor. It finally closed in 1968 and was partially demolished. The site is now the Kwik Save supermarket. The oak tree which was planted here to commemorate the marriage of the Prince and Princess of Wales in 1863 still survives.

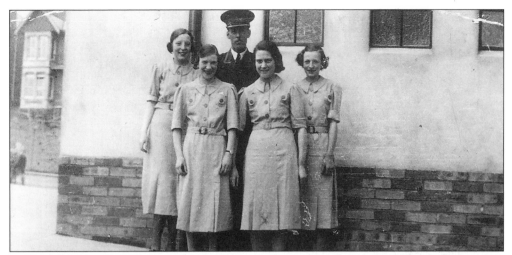

Staff at The Ritz, c.1939. From left to right: -?-, Renee Hambridge, Ted Watson (doorman), Winifred Emery, Joyce Cooper.

Elizabeth Taylor and Richard Burton at the launch of Harlech TV (now HTV), Bath Road, 19 May 1968. The Burtons were the original major shareholders in the television company. Richard Burton had just bought the famous 33 carat Krupp diamond ring for £127,000, and it made its public appearance on Miss Taylor's finger in Brislington, making worldwide headlines. The studios were originally opened in 1960 by TWW who held the ITV Wales and West franchise from 1958 to 1968.

Nellie Robinson (later Mrs Wood) and her sister Emily (later Mrs Shelper) of No 26 Hollywood Road, probably in Holymead Fields, c.1915. Nellie Wood (1902-1987) became well known for the monologues which she wrote and performed at venues all over Bristol, including the Colston Hall.

# Stock List

(Titles are listed according to the pre-1974 county boundaries)

## BERKSHIRE

**Wantage**
*Irene Hancock*
ISBN 0-7524-0146 7

## CARDIGANSHIRE

**Aberaeron and Mid Ceredigion**
*William Howells*
ISBN 0-7524-0106-8

## CHESHIRE

**Ashton-under-Lyne and Mossley**
*Alice Lock*
ISBN 0-7524-0164-5

**Around Bebington**
*Pat O'Brien*
ISBN 0-7524-0121-1

**Crewe**
*Brian Edge*
ISBN 0-7524-0052-5

**Frodsham and Helsby**
*Frodsham and District Local History Group*
ISBN 0-7524-0161-0

**Macclesfield Silk**
*Moira Stevenson and Louanne Collins*
ISBN 0-7524-0315 X

**Marple**
*Steve Cliffe*
ISBN 0-7524-0316-8

**Runcorn**
*Bert Starkey*
ISBN 0-7524-0025-8

**Warrington**
*Janice Hayes*
ISBN 0-7524-0040-1

**West Kirby to Hoylake**
*Jim O'Neil*
ISBN 0-7524-0024-X

**Widnes**
*Anne Hall and the Widnes Historical Society*
ISBN 0-7524-0117-3

## CORNWALL

**Padstow**
*Malcolm McCarthy*
ISBN 0-7524-0033-9

**St Ives Bay**
*Jonathan Holmes*
ISBN 0-7524-0186-6

## COUNTY DURHAM

**Bishop Auckland**
*John Land*
ISBN 0-7524-0312-5

**Around Shildon**
*Vera Chapman*
ISBN 0-7524-0115-7

## CUMBERLAND

**Carlisle**
*Dennis Perriam*
ISBN 0-7524-0166-1

## DERBYSHIRE

**Around Alfreton**
*Alfreton and District Heritage Trust*
ISBN 0-7524-0041-X

**Barlborough, Clowne, Creswell and Whitwell**
*Les Yaw*
ISBN 0-7524-0031-2

**Around Bolsover**
*Bernard Haigh*
ISBN 0-7524-0021-5

**Around Derby**
*Alan Champion and Mark Edworthy*
ISBN 0-7524-0020-7

**Long Eaton**
*John Barker*
ISBN 0-7524-0110-6

**Ripley and Codnor**
*David Buxton*
ISBN 0-7524-0042-8

**Shirebrook**
*Geoff Sadler*
ISBN 0-7524-0028-2

**Shirebrook: A Second Selection**
*Geoff Sadler*
ISBN 0-7524-0317-6

**Winchester from the Sollars Collection**
*John Brimfield*
ISBN 0-7524-0173-4

## HEREFORDSHIRE

**Ross-on-Wye**
*Tom Rigby and Alan Sutton*
ISBN 0-7524-0002-9

## HERTFORDSHIRE

**Buntingford**
*Philip Plumb*
ISBN 0-7524-0170-X

**Hampstead Garden Suburb**
*Mervyn Miller*
ISBN 0-7524-0319-2

**Hemel Hempstead**
*Eve Davis*
ISBN 0-7524-0167-X

**Letchworth**
*Mervyn Miller*
ISBN 0-7524-0318-4

**Welwyn Garden City**
*Angela Eserin*
ISBN 0-7524-0133-5

## KENT

**Hythe**
*Joy Melville and Angela Lewis-Johnson*
ISBN 0-7524-0169-6

**North Thanet Coast**
*Alan Kay*
ISBN 0-7524-0112-2

**Shorts Aircraft**
*Mike Hooks*
ISBN 0-7524-0193-9

## LANCASHIRE

**Lancaster and the Lune Valley**
*Robert Alston*
ISBN 0-7524-0015-0

**Morecambe Bay**
*Robert Alston*
ISBN 0-7524-0163-7

**Manchester**
*Peter Stewart*
ISBN 0-7524-0103-3

## LINCOLNSHIRE

**Louth**
*David Cuppleditch*
ISBN 0-7524-0172-6

**Stamford**
*David Gerard*
ISBN 0-7524-0309-5

## LONDON
(Greater London and Middlesex)

**Battersea and Clapham**
*Patrick Loobey*
ISBN 0-7524-0010-X

**Canning Town**
*Howard Bloch and Nick Harris*
ISBN 0-7524-0057-6

**Chiswick**
*Carolyn and Peter Hammond*
ISBN 0-7524-0001-0

**Forest Gate**
*Nick Harris and Dorcas Sanders*
ISBN 0-7524-0049-5

**Greenwich**
*Barbara Ludlow*
ISBN 0-7524-0045-2

**Highgate and Muswell Hill**
*Joan Schwitzer and Ken Gay*
ISBN 0-7524-0119-X

**Islington**
*Gavin Smith*
ISBN 0-7524-0140-8

**Lewisham**
*John Coulter and Barry Olley*
ISBN 0-7524-0059-2

**Leyton and Leytonstone**
*Keith Romig and Peter Lawrence*
ISBN 0-7524-0158-0

**Newham Dockland**
*Howard Bloch*
ISBN 0-7524-0107-6

**Norwood**
*Nicholas Reed*
ISBN 0-7524-0147-5

**Peckham and Nunhead**
*John D. Beasley*
ISBN 0-7524-0122-X

**Piccadilly Circus**
*David Oxford*
ISBN 0-7524-0196-3

## SURREY

**Around Camberley**
*Ken Clarke*
ISBN 0-7524-0148-3

**Around Cranleigh**
*Michael Miller*
ISBN 0-7524-0143-2

**Epsom and Ewell**
*Richard Essen*
ISBN 0-7524-0111-4

**Farnham by the Wey**
*Jean Parratt*
ISBN 0-7524-0185-8

**Industrious Surrey: Historic Images of the County at Work**
*Chris Shepheard*
ISBN 0-7524-0009-6

**Reigate and Redhill**
*Mary G. Goss*
ISBN 0-7524-0179-3

**Richmond and Kew**
*Richard Essen*
ISBN 0-7524-0145-9

## SUSSEX

**Billingshurst**
*Wendy Lines*
ISBN 0-7524-0301-X

## WARWICKSHIRE

**Central Birmingham 1870–1920**
*Keith Turner*
ISBN 0-7524-0053-3

**Old Harborne**
*Roy Clarke*
ISBN 0-7524-0054-1

## WILTSHIRE

**Malmesbury**
*Dorothy Barnes*
ISBN 0-7524-0177-7

**Great Western Swindon**
*Tim Bryan*
ISBN 0-7524-0153-X

**Midland and South Western Junction Railway**
*Mike Barnsley and Brian Bridgeman*
ISBN 0-7524-0016-9

## WORCESTERSHIRE

**Around Malvern**
*Keith Smith*
ISBN 0-7524-0029-0

## YORKSHIRE
(EAST RIDING)

**Hornsea**
*G.L. Southwell*
ISBN 0-7524-0120-3

## YORKSHIRE
(NORTH RIDING)

**Northallerton**
*Vera Chapman*
ISBN 0-7524-055-X

**Scarborough in the 1970s and 1980s**
*Richard Percy*
ISBN 0-7524-0325-7

## YORKSHIRE
(WEST RIDING)

**Barnsley**
*Barnsley Archive Service*
ISBN 0-7524-0188-2

**Bingley**
*Bingley and District Local History Society*
ISBN 0-7524-0311-7

**Bradford**
*Gary Firth*
ISBN 0-7524-0313-3

**Castleford**
*Wakefield Metropolitan District Council*
ISBN 0-7524-0047-9

**Doncaster**
*Peter Tuffrey*
ISBN 0-7524-0162-9

**Harrogate**
*Malcolm Neesam*
ISBN 0-7524-0154-8

**Holme Valley**
*Peter and Iris Bullock*
ISBN 0-7524-0139-4

**Horsforth**
*Alan Cockroft and Matthew Young*
ISBN 0-7524-0130-0

**Knaresborough**
*Arnold Kellett*
ISBN 0-7524-0131-9

**Around Leeds**
*Matthew Young and Dorothy Payne*
ISBN 0-7524-0168-8

**Penistone**
*Matthew Young and David Hambleton*
ISBN 0-7524-0138-6

**Selby from the William Rawling Collection**
*Matthew Young*
ISBN 0-7524-0198-X

**Central Sheffield**
*Martin Olive*
ISBN 0-7524-0011-8

**Around Stocksbridge**
*Stocksbridge and District History Society*
ISBN 0-7524-0165-3

## TRANSPORT

**Filton and the Flying Machine**
*Malcolm Hall*
ISBN 0-7524-0171-8

**Gloster Aircraft Company**
*Derek James*
ISBN 0-7524-0038-X

**Great Western Swindon**
*Tim Bryan*
ISBN 0-7524-0153-X

**Midland and South Western Junction Railway**
*Mike Barnsley and Brian Bridgeman*
ISBN 0-7524-0016-9

**Shorts Aircraft**
*Mike Hooks*
ISBN 0-7524-0193-9

This stock list shows all titles available in the United Kingdom as at 30 September 1995.

# ORDER FORM

The books in this stock list are available from your local bookshop. Alternatively they are available by mail order at a totally inclusive price of £10.00 per copy.

For overseas orders please add the following postage supplement for each copy ordered:
> European Union £0.36 (this includes the Republic of Ireland)
> Royal Mail Zone 1 (for example, U.S.A. and Canada) £1.96
> Royal Mail Zone 2 (for example, Australia and New Zealand) £2.47

Please note that all of these supplements are actual Royal Mail charges with no profit element to the Chalford Publishing Company. Furthermore, as the Air Mail Printed Papers rate applies, we are restricted from enclosing any personal correspondence other than to indicate the senders name.

Payment can be made by cheque, Visa or Mastercard. Please indicate your method of payment on this order form.

If you are not entirely happy with your purchase you may return it within 30 days of receipt for a full refund.

Please send your order to:

> The Chalford Publishing Company,
> St Mary's Mill,
> Chalford,
> Stroud,
> Gloucestershire
> GL6 8NX

This order form should perforate away from the book. However, if you are reluctant to damage the book in any way we are quite happy to accept a photocopy order form or a letter containing the necessary information.

# PLEASE WRITE CLEARLY USING BLOCK CAPITALS

Name and address of the person ordering the books listed below:

_____

_____

_____ Post code _____

Please also supply your telephone number in case we have difficulty fully understanding your requirements.　　Tel.: _____ - _____

Name and address of where the books are to be despatched to (if different from above):

_____

_____

_____ Post code _____

Please indicate here if you would like to receive future information on books published by the Chalford Publishing Company.

___ Yes, please put me on your mailing list　　___ No, please just send the books ordered below

| Title | ISBN | Quantity |
|---|---|---|
| ................................................. | 0-7524-_____-___ | _____ |
| ................................................. | 0-7524-_____-___ | _____ |
| ................................................. | 0-7524-_____-___ | _____ |
| ................................................. | 0-7524-_____-___ | _____ |
| ................................................. | 0-7524-_____-___ | _____ |
| | Total number of books | _____ |

**Cost of books delivered in UK =** Number of books ordered @ £10 each =£　_____

**Overseas postage supplement** (if relevant)　　　　　　　=£　_____

**TOTAL PAYMENT**　　　　　　　　　　　　　　　=£　_____

Method of Payment　　❑ Cheque　　❑ Visa　　❑ Mastercard

Please make cheques payable to *The Chalford Publishing Company*

**VISA**

**MasterCard**

Name of Card Holder　　_____

Card Number　❑❑❑❑❑❑❑❑❑❑❑❑❑❑❑❑❑❑❑❑

Expiry date　❑❑ / ❑❑

I authorise payment of £_____ from the above card

Signed _____